Philip Mackenzie.

ALL THE PAINTINGS OF
PIETER BRUEGEL

VOLUME ONE
in the
Complete Library of World Art

ALL THE PAINTINGS

OF PIETER BRUEGEL

Edited by VALENTIN DENIS

Translated from the Italian by
PAUL COLACICCHI

OLDBOURNE
London

Printed in Great Britain by
Jarrold and Sons Ltd, Norwich

CONTENTS

PIETER BRUEGEL

Life and Work

IT is customary to include in the front ranks of the greatest masters of art those who have created and personified a vast movement of innovation. Among such men were Jan van Eyck, creator of fifteenth-century Flemish painting, and Peter Paul Rubens, who dominated the Baroque art of the southern region of the Netherlands. These artists were able to synthesize the general tendencies of their time and to discover a mode of expression that was to prevail over that of the majority of their contemporaries. Each of these founders of a school embodied an artistic style peculiar to his own epoch, and their personalities are still so powerful and authoritative that, even long after their death, no artist manages to escape their influence.

Only men of exceptional strength of character have managed to remain untouched, or almost untouched, by the stylistic conventions generally accepted in their society. This is the case with Pieter Bruegel the Elder, or "Peasant" Bruegel, whose name we find variously written as "Breugel" or "Breughel". His connexions with the sixteenth century are so few, particularly if one takes into account the numerous and often revolutionary innovations introduced by this vigorous personality, that he seems to belong to the Renaissance only by the sheer coincidence of his date of birth. His indifference was almost absolute towards even the most inviolable artistic principles established at the end of the

fifteenth century by the great Italian masters, in spite of the fact that these principles were law over the whole of Europe, and that the Netherlands themselves were certainly not lacking in followers of the Italian or Roman Schools. Pieter Bruegel ignored them all. His self-reliant temperament must surely have inspired him with nothing but feelings of contempt and pity for the generally mediocre followers of a foreign art. His independent nature forbade him any form of imitation, even if cleverly concealed.

He made it a point of honor not to borrow any definite formal element from the Italian Renaissance or from the old pictorial tradition of his own country. His original spirit was the bearer of an entirely new message, and he was endowed with sufficient imagination to express it in painting by creating a world of his own. In addition, he developed a very individual technique. It may therefore be said that in the works of Pieter Bruegel everything belongs to their author: the choice of subject, the form, and the execution. These were the constituents of his art and they were so inextricably fused together that they prevented not only the emergence of a Bruegel School, but also of a single pupil worthy of the master. In the midst of a multitude of mannerists, feverishly engaged in copying Italian art and in spreading it through Flanders, Bruegel appears as an isolated genius.

Everything in his work is so new and astonishing that, three centuries after his death, he is still as greatly misunderstood today as he was when alive. No doubt his works were in demand up to the beginning of the eighteenth century. They could be found, in good numbers, in the homes of the most distinguished collectors of the period, people like Cardinal de Granvelle, the Archduke Albert and the Archduchess Isabella, Rubens and the Emperor Rudolf II.

But at the time only the burlesque side of his compositions

seems to have impressed the art-lovers. At least, such is implied by the unanimous judgements passed by the writers of the period, who speak of him as a second Hieronymus Bosch, calling him by the nickname of "Pierre-le-Drôle", and limiting themselves to underlining the anecdotal and jocular character of his paintings. And this is understandable, as it is understandable that the over-refined eighteenth century and the pretentious nineteenth century should have seen him as an uncouth village painter, accusing him of vulgarity and even of banality. Only one art historian of the eighteenth century, J. P. Mariette, realized the greatness of Bruegel. Not until the years after 1860 do we find the first vigorous protest against the low opinion or derogation expressed until then in every allusion to the master, and it is only in the first years of our own century that we have seen the publication of fundamental critical studies which give a more exact and complete understanding of this painter. These studies, sustained and integrated by an ever-growing number of publications and by more abundant and perfect photographic reproductions have by now reawakened the interest of the public in Bruegel.

This general but very recent enthusiasm explains why museums have waited so long before buying works by the master. The Vienna Museum has long contained the richest collection, inherited from the Hapsburgs. But a true and apt policy of acquisition only began fifty or, at the most, sixty years ago with the buying of *The Cripples* by the Louvre in 1892. In 1846 the Royal Museum of Brussels acquired *The Fall of the Rebel Angels*, but this was only because the work was then attributed to Hieronymus Bosch. It is difficult to believe today that before 1914 and 1920 the museums of Berlin and London did not possess a single work by Bruegel. There are still many countries, including

9

Holland itself, in whose galleries the great master is not represented.

Among the documents which have remained to give posterity some information about Pieter Bruegel, the so-called *Schilderboek* or *Book of Painters*, by Carel van Mander, published in Haarlem in 1604, is of particular importance. This conscientious historian was, though younger, a fellow-countryman and a contemporary of the master and, having been introduced into Flemish artistic circles, presumably gathered his facts directly from Bruegel's friends and possibly from members of his family. He is the first writer and perhaps the only one who has left us an almost complete biography. The majority of his facts have been confirmed by the most recent studies and this gives his narrative a more than adequate degree of truth. It is a pity that he omitted the date and place of birth. But it is possible, on the basis of his book and of others, to give a broad outline of Bruegel's life and to gather some interesting facts about his art.

Pieter Bruegel was very likely born between 1525 and 1530 in the countryside of Brabant, and we often find pictured in his work the wide and fascinating plains of that border region between Belgium and Holland, particularly in *The Proverb of the Bird's Nest*, and in one of his very best works, *The Misanthrope*. From his early youth Bruegel must have felt deeply the beauty of that simple but ever-changing countryside, to whose subtle charm we owe that love of landscape which was to remain until the very end of his life one of his greatest, if not his dominant, interest. However, as is often the case, in his formative years the artist did not discover immediately his real "forte": the direct observation of nature and of the ragged but lovable peasants who are so admirably at one with their surroundings.

It is not improbable that in the Campine, not far from

Bois-le-Duc, he was very soon attracted by the fantastic and ironic art of Hieronymus Bosch: early paintings like *The Adoration of the Magi* and *The Fall of the Rebel Angels* recall, and indeed, surpass, some of the best work of the master of Bois-le-Duc. But everything tends to confirm that Bruegel served his apprenticeship in Brussels in the workshop of Pieter Coecke, of Alost. The latter died in 1551 and his pupil settled in Antwerp where, that same year, we find him among the members of the Guild of St Luke.

It is hardly necessary to recount the enormous influence of Pieter Coecke in the Netherlands: a fervid admirer of Raphael and translator of Serlio, he completely transformed the style of landscape painting current among the Flemish painters of his time. Young Bruegel did not manage to escape his influence altogether, and in particular inherited from him the desire to visit Italy, whose great masters were the cult-objects to artists of all countries. Before his departure to the Alps, we find Bruegel in the studio of the publisher, Hieronymus Cock, a humanist in the Italian tradition, and therefore an authoritative propagandist of Italian art in Antwerp. This, however, did not prevent him from appreciating and encouraging the best of local art, as proved by the fact that in addition to reproductions of sub-alpine masterpieces he published works by Hieronymus Bosch. And it was Pieter Bruegel who was entrusted with the preparation of the first drawings, many of which have come down to us. It is not fanciful, therefore, to suppose that in the workshop of "The Four Winds" in Antwerp, Pieter Bruegel dimly saw the possibility of a skilful and advantageous fusion in his work of the specific qualities of the south and of the north.

Fired by the general passion for Italian art, Bruegel left the Netherlands in 1552 to visit France and especially Italy,

including Naples and Sicily. It would be going too far to pretend that, faced with the greatest masterpieces of the peninsula, he did not recognize their value. On the contrary, a careful examination of his own paintings shows that he was sometimes able to assimilate them. But it must be said that, unlike so many of his countrymen who visited Italy, he did not copy a single work on the spot; none of his numerous drawings, none of his sketches ever recalls a Florentine or a Roman fresco, a Venetian or a Neapolitan painting. But there is more: neither during his stay south of the Alps nor later did Bruegel ever appropriate any external form belonging to the aesthetics of the Renaissance. His was a total independence, a really unique phenomenon in the sixteenth century.

He seems instead to have been completely captivated by the mountainous landscapes of Italy and France: this is apparent in his first dated work, a drawing of 1552. Furthermore, he returned to Antwerp a year later with an important series of Alpine drawings, sketched on the spot, and it is tempting to believe that Hieronymus Cock paid for his journey after entrusting him with the task of bringing back some "views" of the regions which were then the most popular with lovers of art.

Whatever the means and the object of that journey, it strongly influenced Bruegel's successive works. On several occasions unforgettable memories enabled him to draw some impressive mountain scenes as in *The Suicide of Saul*, or *The Conversion of St Paul*. Admirable compositions were similarly inspired by the southern seas, as is proved by *The Harbor at Naples* and *The Fall of Icarus* (around 1558), which for some brings to mind a memory of the Straits of Messina.

Italy exerted upon Bruegel, therefore, a felicitous and lasting influence: in many of his works it is possible to catch

something of the deep emotion that the artist felt in front of blue and green seas trembling in the sunlight, or of gigantic mountains, arid and aloof. As far as Italian art is concerned Bruegel, though hostile to any imitation, assimilated some of its essential principles: the science of composition, the decorative sense, the infinite wealth of color and, even more, the aerial illusion of space and the plastic definition of beings in motion. In the majority of his works, however, the painter made a precise choice among these characteristics according to the necessities of each subject, and only a very careful study will enable one to detect them, because his forms are never really Flemish or Italian, but always and only Bruegelian.

Enriched by his long experience abroad, Pieter Bruegel returned to Antwerp in 1553 and tried to find his way through the contrasting tendencies which formed his artistic make-up. A prudent and modest man, as his countrymen generally are, he seemed at first to be content with drawings and engravings and produced in these fields some masterpieces of technical virtuosity and refined sensitivity. The first paintings that can be attributed to him do not seem to have been done prior to 1557 and they betray the uncertainty of an artist who has reached a crossroad in his career. Already sure of his atmospheric effects, in the delightful view *The Harbor at Naples* he gives us a brilliant symphony of dark greens and orange-yellows, while in his only mythological painting, *The Fall of Icarus*, he sings of the glowing natural beauties of the peninsula. Nor does he remain indifferent to the landscape of the Campine, which appears in the *River Landscape with Peasant Sowing*. Bruegel, however, still seems to be dominated by the personality of that bizarre painter of genius, Hieronymus Bosch, who marks the borderline between the fifteenth and

sixteenth centuries in the Netherlands. Following in his wake, Bruegel seeks to create comic and burlesque effects—even in the works of religious character—through a host of robust peasants placed next to or standing beside exotic personages dressed in the most curious costumes, the whole conceived with openly caricatural intentions. That this was so is proved by one of his very first paintings, perhaps the oldest, *The Adoration of the Magi* in the Royal Museum of Brussels. The same tendency is revealed in *The Wine of St Martin* and in the *Twelve Proverbs* in Antwerp. From the purely representative point of view these first pictorial essays by Bruegel already prove him to be a bold innovator, although the human figures and the landscapes are still treated as separate entities. There is no connexion between them: the surroundings do not yet tolerate, or at least appear to resent, the presence of human figures and these, always small, are often so numerous as to prevent any real enjoyment of the landscape. The two great secular works of 1559, *The Netherlandish Proverbs* in Berlin, and *The Battle between Carnival and Lent* are derived, in spite of the important progress achieved, from the same source. As well as clear memories of Bosch, we already find in them some of the tendencies peculiar to Bruegel: every scene, for instance, is seen from above and a great respect for the laws of composition induces the painter to stress the main lines of the painting, thanks to which the throng of minute and gesticulating figures does not appear inextricably confused. Similarly, an already skillful and harmonious use of colors preserves the qualities of clarity, unity, and coherence in every one of these paintings. It still remains, however, an eminently anecdotal art, of decidedly popular appeal.

In spite of this Bruegel did not set out to speak to the people. He never worked for public bodies, neither religious

nor lay. Only on the eve of his death did the City Council of Brussels entrust him with its first official commission; but the painter was no longer capable of fulfilling the assignment. As for the ecclesiastical authorities, it is understandable that the revolutionary character of his treatment of even the most traditional religious themes should consistently have caused them some anxiety and doubt. In general, Bruegel addressed himself to an elect minority, well informed, cultured, and refined. In spite of his peasant origin, Bruegel had acquired a wide and solid culture and was often seen in the company of the intelligentsia like the geographer Ortelius and the humanist, Coornhert. The collections of such great patrons of art as Cardinal de Granvelle seem to represent the natural destination of his works.

All those people who took an active part in the enthusiastic movement of ideas and in the great cultural rebirth to which it led, must have found great pleasure in the contemplation of his first easel paintings, which they could quietly enjoy even before exhausting their rich and varied representative content. These well-informed and progressive men must have taken a particular interest in discovering the true and deep meanings of a thousand subtle details. Then as now one who studies carefully all the representative elements in Bruegel's compositions finds himself confronted with an infinity of allusions that can best be understood by men equipped with considerable knowledge, not only of the ancient classics and old local literature, but also of the imaginative customs and language of the common people. Like Rabelais and Shakespeare, Bruegel adopted the slightly pretentious fashion of his time: a show of learning, perhaps sometimes too pedantic, hidden under everyday appearances. His learned contemporaries had a passion for discovery and Bruegel, with his exceptionally fertile and fantastic

imagination, found no difficulty in giving to many of his paintings, particularly in this first period, the appearance of cleverly contrived puzzles. Nevertheless, the paintings of the master maintain their popular tone because, as we have already suggested, it is among the working class, and particularly among the peasants, that he finds his markedly masculine or feminine types and the humor, sarcastic but devoid of bitterness, the unceasing geniality, the deep-rooted optimism, the profound love of nature and finally a particular language, colorful and suggestive.

By 1560 the period of experiments and hesitations seems to end. It is then that the painter executed his famous *Children's Games*, his first fully original work, free from every outside influence and rich in qualities exquisitely Bruegelian. Contrary to what is suggested by a first impression, due to the decidedly Flemish character of the landscape, Bruegel seems to have adopted here the principle, if not the scheme, of his composition from Italian art. This outside influence is skillfully and very successfully camouflaged, as it establishes the balance of the painting which otherwise, because of the large number of small figures and their turbulence, might have turned into a confused mass. An extremely clever solution indeed, based on the introduction of the feverish vitality of a disorderly multitude into a very definite architectural frame—a device already partially present in *The Battle between Carnival and Lent* and noticeable by its absence in *The Netherlandish Proverbs*.

This period of activity is followed by the painting of several Biblical subjects in the heroic mood, some of which seem to confirm the deep and obsessive influence exerted by Hieronymus Bosch on the young man. *The Fall of the Rebel Angels* is enough to show the truth of this, because the conception of the master of Bois-le-Duc appears again very

clearly in the struggling and confused mass of rebel angels, whom the artist represents as strangely shaped monsters, often in the most unexpected attire and in the most grotesque attitudes. The powerful figures of the faithful angels scan the rhythm of the painting which, in spite of everything, acquires a great sense of unity from the rich and warm harmony of colors, while thanks to a very skillful use of perspective the sudden opening of the sky, in the central top part of the painting powerfully suggests the immensity of space.

In front of *The Triumph of Death* one still thinks, though much less, of Hieronymus Bosch: it is the gigantic and terrifying vision of a powerful mind; the very fact that he was able to achieve such a magnificent fusion of two traditional themes (the "Danse Macabre" and "The Last Judgement") enables us to gauge the extraordinary personality of the creator and to understand the public interest in his successive work. In the foreground the representatives of all social classes are falling under the blows of Death and his terrifying henchmen; only two lovers, on the right of the painting, have not realized the danger. Farther away desolation is complete, while on the horizon sinister gleams of light evoke the atmosphere of a frightful massacre. To the same source of inspiration we owe another important painting of those years, representing "*Dulle Griet*" or *Mad Meg*; this, too, is a traditional subject which recalls, for example, the *Bruja*, or *Witch*, by Hieronymus Bosch. As Terlinden writes, "Mad Meg is, in the folklore of the time, the personification of the hag, of a diabolic tribe of women whom nothing can stop and who are ready to defy Satan at the very doors of Hell."

We must now leave aside all the arbitrary and anachronistic interpretations of Bruegel's works proposed by quite a few critics who, compelled to solve many a puzzle in order to

explain their meanings, have ended by seeing political allusions in almost every one of them. In 1567 Philip II ordered the suppression of Flanders. To confirm the independence of inspiration from these tragic events, it is enough to stress the fact that while some cruel and tormented compositions were produced by Bruegel before this date in a period of peace and prosperity, those conceived and executed later at the height of the unrest and violence and in the midst of sorrow and misery, are devoted to amusing themes. This confirms that the artist took no part whatsoever in political controversies and battles: there is nothing in the whole of his work to justify the opposite view.

Returning to Antwerp where he had lived since 1551, after his journey through France and Italy, Bruegel led an active and carefree life. Antwerp, thanks to its model harbor, was eminently cosmopolitan and must then have been full of absorbing interest for an artist so endowed as an observer and psychologist. There one could meet the great merchants and adventurers of the sea, the free spirits of the fields of philosophy and religion, and the artistic aristocracy of the country. For this reason the most diverse personalities appear as acquaintances and friends of Bruegel: we have already mentioned Ortelius and Coornhert, and we must now add to the group of his intimates a Nuremburg merchant, Hans Franckert who, as a member of the "House of Rhetoric of the Metropolis" from 1546, must have been an excellent companion for the painter during his hours of relaxation. It is interesting to imagine Bruegel in the whirlwind of the "Kermesses", or Saints' Days, organized in the villages around the town, where he went to maintain his necessary contacts with the people of the countryside.

In 1564 Bruegel executed three important religious

paintings: *The Adoration of the Magi* (now in London), *The Road to Calvary*, and *The Death of the Virgin*. Notwithstanding the artistic tendencies of the country and the examples of the Italian Renaissance, Bruegel managed to give new life to these ancient themes and the eminently personal freedom with which the evangelic subjects were treated by him reveals a spiritual independence which goes beyond the borders of art into the realm of faith. To realize this fully one must understand his attitude towards the innumerable and ever-intriguing Protestant sects in the Netherlands of that time. His autonomy towards these religious struggles must have been as absolute as it was in relation to the pictorial ideals of the time. Judging from his works, one is led to believe that he was deeply interested in the writings of Erasmus of Rotterdam, whose *In Praise of Folly* is spiritually present in all his work. Living as he did in the very free atmosphere of Antwerp and surrounded by friends who were at least in principle captivated by the new ideas, Bruegel must have felt a certain interest in if not a real sympathy for Protestantism. And if it is true that the iconoclastic violence filled him with disgust for all these rival sects, it is also true that, like Erasmus, Rabelais, and so many others, he was always to remain attached and faithful to a broader concept of liberty: the spirit of Christ and the Gospel certainly carried a greater weight with him than all the dogmas of the contrasting religions. In spite of this, almost half his works illustrate themes taken from the Bible. But it is enough to look at his paintings to realize that his faith is no longer comparable to that of his great predecessors of the fifteenth century. His attachment to worldly things and to the common people is so strong that he brings even the most sacred subject down to a human and everyday level. Even more than in the compositions of a non-religious

character, the subject becomes secondary and is lost in a spacious landscape which seems to absorb the whole interest of the painter, as we can see in *The Road to Calvary*, which we have already mentioned, and in one of the purest of his masterpieces, *The Numbering of the People at Bethlehem*. In both cases the sacred characters are so similar in appearance to the other figures in the composition that it is quite difficult to distinguish them from the rest of the crowd, and they are not given even the most modest halo.

This revolutionary lack of religious feeling must, at the beginning, have frightened the artist himself who, to make it less obvious in *The Road to Calvary*, painted the group of holy women and the Apostle John after the style of the previous century. This group stands out clearly from the rest of the painting. But two years later in *The Numbering of the People at Bethlehem* he discarded his former scruples: here nothing represented is but the collection of taxes in a small village of the Brabant in the heart of winter. It would be difficult to maintain that this work originates from a deep and sincere piety or that it is edifying for the onlooker. The same may be said of *The Adoration of the Magi* which is rather theatrical. As far as *The Death of the Virgin* is concerned, in the end it is nothing but the death of a poor woman in a common district; in the two versions of *The Tower of Babel*, the Biblical theme is only a pretext for the representation of a phantasmagoric structure; and sometimes the connexion with the sacred text is even more tenuous, as in *The Parable of the Blind*.

This most original way of treating religious subjects leads one to suppose that Bruegel was to reach the peak of his art in landscape painting, which is a genre exquisitely secular. He was to find his own way of expressing his love for nature, showing it as radiant or threatening, tranquil

or agitated, benign or oppressive. In 1565 this was to lead to the stupendous series of the "Months" or "Seasons": *The Stormy Day*, *The Return of the Herd*, *The Hunters in the Snow*, *Winter Landscape*, *The Hay Harvest*, and *The Corn Harvest*. One is astonished by the ability with which Bruegel expresses all his feelings of enchantment and attraction towards nature in his paintings. His greatness as a landscape painter is beyond praise. He manages to convey the peculiar atmosphere which permeates them as well as giving a realistic rendering of each landscape. It is certain that the landscape as a genre, as an end in itself, is not yet his sole aim, and he only dares to tackle it as a background to scenes of a religious or profane nature; he still needs a pretext. But he shows in this way how much nature has become his dominant preoccupation, continuous and independent of the chosen theme. In all his views of sea, plains, or mountains, Bruegel reveals an admirable capacity for synthetic vision: he catches the essential lines, and instinctively completes them with the mood of the climate, the season, and the hour. If, at the beginning of his career, the small figures are still too numerous and at least at first sight, hide the solid composition and delicate colors of the landscape (we have noticed this in *Children's Games*), in the series of masterpieces which are the "Months", Bruegel attains a perfect balance between the elements of nature and the human beings who enjoy her providential gifts, or struggle against her blind and crushing violence.

One is justified in saying that Bruegel's evolution is really the product of his growing attachment to nature and of his progressive detachment from traditional iconography. Around 1557–8 his compositions, even then purely imaginary, are filled and complicated by a mass of figures which stifle even the least breath of landscape. Observe,

for instance, *The Adoration of the Magi* in Brussels, and the *Wine of St Martin*. Very soon the figures, reduced to smaller dimensions, move in panoramic surroundings not devoid of effectiveness, as in *Children's Games*, though the way of grouping this swarm of children remains unrealistic and imaginary. It is not until 1565, and the "Months", that we find a frank and true representation of a labouring humanity, moving at ease in a natural framework of magnificent breadth.

For some time, the master had already given proof of a spontaneous preference for reality: the *Twelve Proverbs* of Antwerp and the *Head of an Old Peasant Woman* confirm it eloquently. The same may be said of *Two Monkeys*; Bruegel shows extraordinary gifts as an animal painter in this lively and impressive study of two red-headed African monkeys which, in spite of their prodigious truthfulness, do not manage to distract the attention entirely from the delicate panorama of the harbor of Antwerp in the background. From 1565 onwards Bruegel remained faithful to his predilection for landscape, and in the last years of his life he evoked in a delicate and moving way the vast plains of his native Campine: the outskirts of a quiet and modest village of Brabant form the backcloth for the impressive and unforgettable silhouettes of the painting, *The Parable of the Blind*, and a farm of the same region, obviously true to life, is without doubt the most successful and attractive part of *The Proverb of the Bird's Nest*.

In this context we must stress the extremely original technique which can be seen in all Bruegel's works, but especially in the landscapes. We no longer have the broad, uniform color surfaces adopted by his great predeces sors of the fifteenth century in the Netherlands: those flat colors almost always managed to catch the physical

quality of the object but did not take into account their real change under the impact of natural or artificial light. It is these effects of light, on the contrary, these vibrations of the object in the sun, which seem to have caught Bruegel's imagination. It is not surprising, therefore, that he should have adopted an impressionistic technique *avant la lettre*, based on the skillful juxtaposition of an infinite number of different and sometimes contrastingly colored spots, painted with minute and nervous brush-strokes, which allowed him to imprison the light. Perhaps better than anywhere else, this can be seen in the amusing and bizarre composition, *The Land of Cockayne*. In this dream land the three main social classes are represented: the warrior, the peasant, and the man of letters, and every detail of their attire as well as the tree-trunk in the center, is evoked by means of a divisionistic technique whose first object is to evoke the fugitive vibrations of light. Contrary to what happens in the works of nineteenth-century Impressionism, this technique does not detract in any way from the plasticity of appearances; in Bruegel's work all objects and all figures maintain their tangible volume and physical weight and the rotundity of the three main figures is rather striking. The same may be said of *The Cripples*. Generally speaking, in Bruegel these large or small figures, usually squat, rather plump and quite solid, always play an important part and the painter manages to give them a strong vitality by showing, for example, a torso turned at a different angle from the hips. From this point of view the *Children's Games* presages *The Wedding Dance in the Open Air*, and *The Dance of the Peasants*, the so-called *Kermesse*.

In 1563, according to the marriage registers of the Church of Notre-Dame-de-la-Chapelle, in Brussels, preserved in the city archives, Pieter Bruegel married Marie Coecke,

the daughter of his old master. At the request of his mother-in-law he left Antwerp and settled in Brussels. Was this a consequence or a mere coincidence? It is certainly surprising that so many of his paintings between 1565 and 1568 illustrate village weddings and country fêtes—*The Wedding Procession, Peasants Dancing before the Inn, The Wedding Dance in the Open Air, The Merry Way to the Gallows, The Peasants' Wedding,* and *The Dance of the Peasants.* The choice of subject is more and more optimistic and gay, and Bruegel multiplies in his paintings the scenes of merrymaking, touching the peak of his art, which is always a warm and impassioned testimony to his innate affection for the good people of the fields and to his growing sensibility towards the beauties of nature. There is only one painting in these last years of his life that seems to betray some philosophical preoccupations and a certain discouragement, *The Misanthrope.* It is one of his highest achievements: here we see a stately old man, disappointed by the ingratitude and faithlessness of human beings, wandering through a vast Campine plain in Brabant; his ample, hooded black cloak is thrown back to reveal only the hands folded in prayer, the nose, and the white beard. The artist—who is painting the land where he was born—conveys his infinite sadness with brief, rapid, and delicate brush-strokes.

The last work that can be attributed to Bruegel with certainty is the *Storm at Sea,* composed with fiery mastery. We will have to wait a long time before seeing again a seascape as impressive as this. But this powerful and all-embracing vision does not prevent the artist from remaining, as in the majority of his works, faithful to a taste for riddles: the whale in the foreground is an allusion to the old Flemish proverb: "If you follow the barrel you lose the ship."

A register kept in the City Hall of Brussels testifies that

on January 18, 1569, the City Council granted an advance to "Meesteren Pieteren van Bruegel", on account of what was undoubtedly the first commission that the painter had received from a public authority. But he was not to carry it out. An epitaph in the Church of Notre-Dame-de-la-Chapelle announces that Pieter Bruegel died that same year, perhaps on September 5, in Brussels. Carel van Mander says that, before dying, Bruegel advised his wife to destroy some drawings, very probably caricatures of well-known personalities, which could have created difficulties for his widow. According to the same chronicler, the widow inherited, among other things, the painting *The Merry Way to the Gallows*; the intention of the painter does not seem to be very flattering for the recipient, for the meaning of this work seems to be "to the gibbet with all wicked tongues".

Marie Coecke died in 1578 and was buried beside her husband. The two sons of Bruegel were excellent painters, although they did not attain their father's eminence. Pieter, known as "Hell" Bruegel or Bruegel the Younger, was content to copy the works of his father, and Jan Bruegel the Elder, often known by the sobriquet of "Velvet" Bruegel, specialized in still-lifes of flowers and in landscapes enlivened by the presence of a great number of glossy coated animals. He repeatedly collaborated with Peter Paul Rubens.

BIOGRAPHICAL NOTES

1525–30. Pieter Bruegel the Elder is born in the Campine of Brabant, but no document is precise as to the place and date.

1545–50. He studies painting with the master, Pieter Coecke of Alost, in Brussels.

1551. The "liggeren" or registers of the Guild of St Luke, the corporation of painters in Antwerp, mention his name for the first time. He starts work in the workshop of "The Four Winds" belonging to the publisher, Hieronymus Cock, and produces drawings for engravings.

1552–3. He travels to France and Italy and brings back numerous landscape drawings and sketches.

1557. The first signed and dated painting, *River Landscape with the Peasant Sowing.*

1563. He marries the daughter of his old master, Marie Coecke, in the Church of Notre-Dame-de-la-Chapelle in Brussels. According to his biographer, Carel van Mander, he used to live with a servant-girl in Antwerp. To bring this relationship to an end his mother-in-law insisted that he move to Brussels, where he remained to the end of his life.

1564. Birth of the first son, Pieter the Younger, known as "Hell" Bruegel.

1567. The first of all future chroniclers, Ludovico Giucciardini, mentions Pieter Bruegel in his *Descrittione di tutti i Paesi Bassi (Description of all the Low Countries).*

1568. Birth of the second son, Jan, often known as "Velvet" Bruegel.

1569, JANUARY 18. The Brussels City Council makes the double decision of exempting the master from the duty of billeting Spanish soldiers and of granting him an advance on the commission of a painting.

1569, SEPTEMBER 5 (?). Pieter Bruegel dies. A memorial will later be erected by his son Jan in the Church of Notre-Dame-de-la-Chapelle in Brussels.

1578. Death of his widow.

1604. Carel van Mander writes the first biography of the master in his *Schilderboek,* or *Book of the Painters.*

BRUEGEL'S WORKS

Color Plate I

THE PARABLE OF THE BLIND, detail of central part. (See also plates 138–42.)

Plate 1

THE ARCHANGEL MICHAEL. *Tempera on panel, 43 × 29 cms. Eindhoven, Collection of Dr A. F. Philips.* Previously in the collection of Dr Vitale Bloch of Berlin. Date *c.* 1557 (?). Attribution sometimes contested. The Angel recalls the art of Mantegna.

Plate 2

RIVER LANDSCAPE WITH PEASANT SOWING, or THE ESTUARY. *Tempera on panel, 74 × 102 cms. Antwerp, Collection of Stuyck del Bruyère.* The earliest painting signed and dated by the master: "Bruegel 1557." In bad condition. Copies in the Prado Museum of Madrid and in the Galerie Manteau of Paris. (See Attributed Paintings.)

Plate 3

THE ADORATION OF THE MAGI. *Tempera on canvas, 115·5 × 163 cms. Brussels, Musées Royaux des Beaux-Arts de Belgique.* Acquired in 1909 at the Fétis sale in Brussels, previously acquired at a public sale in the same city. 1557 (?).

Plate 4

TWELVE PROVERBS. *Tempera on panel, 74 × 97·5 cms. Antwerp, Mayer van den Bergh Museum.* Signed and dated 1558 (?). Ingenuous illustration of old Flemish sayings: each proverb is represented by one single character on a red background, The twelve little panels were painted separately on the bottoms of plates and were very likely made into a single unit at the end of the sixteenth century; the following twelve inscriptions were then added to them:

1. To go on drinking when you are already drunk reduces you to poverty, dishonors your name and leads you to ruin.
2. I am an opportunist and such is my character that I always turn my coat where the wind blows.
3. With one hand I carry the fire, the water with the other, and spend my time with gossips and tale-bearers. (Old hags sow disharmony (?).)
4. In carousing none was my equal; now, reduced to poverty, I find myself between two stools sitting on the ashes.
5. The calf looks at me with empty eyes. What's the use? I cover the well after he has already drowned. (Belated remorse is useless; one must foresee the future.)
6. He who likes to do useless work throws roses to swine. (Good deeds should be reserved only for those who deserve them.)
7. The armor makes a brave warrior of me; and I tie a bell round the cat's neck. (A soldier's uniform makes even a coward brave.)
8. My neighbor's good luck torments my heart; I cannot bear

the sun shining on the water. (The envious oppose the happiness of others.)

9. I am belligerent, proud, and choleric; as a result, I run my head against a wall. (Irascibility is the cause of a man's own misfortune.)

10. One man's meat is another man's poison. I always fish behind the net. (The bungler works to no purpose.)

11. I hide under a blue cloak; but the more I hide the more I am recognized. (The faithlessness of the wife makes the husband famous in spite of himself.)

12. All my pursuits are vain; I always p—s on the moon. (One must not set one's sights too high.)

This simple, but vital and witty work, which already reveals a great sureness of touch, is clearly attributed to Bruegel in the sale of the paintings belonging to Nicolaes Cheeus which took place in Antwerp in 1621. However, its authenticity has been doubted because the same twelve panels are attributed to Pieter Bruegel the Younger in the inventory of the goods of the widow Cheeus, drawn up in 1663. This kind of medallion painting seems, however, to be common in the production of the master, as is confirmed by some inventories of the seventeenth century, including one made in Antwerp in 1640 of Peter Paul Rubens. (See also plates 5–7.)

Plate 5

TWELVE PROVERBS, details. First and third panels.

Plate 6

TWELVE PROVERBS, details. Seventh and eighth panels.

Plate 7

TWELVE PROVERBS, details. Ninth and twelfth panels.

Plate 8

THE HARBOR AT NAPLES. *Tempera on panel, 47 × 70 cms. Rome, Galleria Doria.* Approximately 1558 (?). Attribution sometimes contested, though the painting seems to appear in the inventory of the family de Granvelle, Besançon, 1607, and in that of Peter Paul Rubens, Antwerp, 1640. Remarkable for the harmony between the bronze-green of the sea and the glowing yellow of the sky.

Plate 9

LANDSCAPE WITH THE FALL OF ICARUS. *Tempera on canvas, 73·5 × 112 cms. Brussels, Musées Royaux des Beaux-Arts de Belgique.* Acquired in London from the trade in 1912. Approximately 1558 (?). Painted on panel, but transferred to canvas in recent years (around 1900). The only painting with a mythological theme in the catalogue of the master; the numerous flaws have caused and are still causing doubts about the attribution. Copy in Paris, in the J. Herbrand Collection. (See Attributed Paintings, and plate 10.)

Plate 10

LANDSCAPE WITH THE FALL OF ICARUS, central detail.

Plate 11

THE WINE OF ST MARTIN. *Tempera on canvas, 92·5 × 73·5 cms. Vienna, Kunsthistorisches Museum.* Approximately 1558 (?). Badly preserved fragment of a large painting known through various works, including a copper engraving by H. Guérard, the original of which was attributed by Abraham Bruegel (1631–c. 1690) to his grandfather, Pieter Bruegel the Elder.

Plate 12

THE NETHERLANDISH PRO-VERBS. *Tempera on panel, 117 × 163 cms. Berlin, Staatliche Museen.*
Acquired from an English private collection in 1914. Signed and dated 1559 (the original date, 1569, is supposed to have been corrected by the author himself). This composition, rather crowded but very pleasant, illustrates more than a hundred Flemish proverb and sayings. A copy by Pieter Bruegel the Younger is kept in the Frans Hals Museum in Haarlem. (See also plates 13–18.)

Plate 13

THE NETHERLANDISH PRO-VERBS, detail. "He is sailing with the wind behind him." "He sees dancing bears" (to be hungry). "Fear makes the old women trot."

Plate 14

THE NETHERLANDISH PRO-VERBS, detail. "The world turned upside down." "They lead each other by the nose." "The die is cast." (It all depends on how the cards are dealt, on how things go, etc.)

Plate 15

THE NETHERLANDISH PRO-VERBS, detail. "He is armed to the teeth." "Who shall put the bell on the cat's neck?"

Plate 16

THE NETHERLANDISH PRO-VERBS, detail. "To run one's head against a wall", etc.

Color Plate II

THE HUNTERS IN THE SNOW. (See also plates 88–94.)

Plate 17

THE NETHERLANDISH PRO-VERBS, detail. "One holds the distaff and the other spins" (slander grows by passing from mouth to mouth). "'Tis ill shearing against the wool."

Plate 18

THE NETHERLANDISH PRO-VERBS, detail. "It is ill fishing behind the net" (to act aimlessly).

Plate 19

THE BATTLE BETWEEN CARNI-VAL AND LENT. *Tempera on panel, 118 × 164·5 cms. Vienna, Kunsthistorisches Museum.* Signed and dated 1559, this painting, which came from the *Weltliche Schatzkammer* of Vienna in 1748, is undoubtedly the one mentioned by van Mander; it also seems to be referred to in the inventory of Philips van Valckenisse made in 1614 and in the one of Herman de Neyt in 1642. In 1748 it passed to the Imperial Gallery of Prague; and then to the Kaiserliche Burg in Graz, finally reaching Vienna in 1765. There is a copy in the Copenhagen Museum. (See Attributed Paintings.) The painter has set the scene of this traditional allegory in a crowded village square. On the left, towards the center, the group of miserable cripples seems to be a forerunner of the painting, *The Cripples*, in the Louvre (1568). For the first time, a surer sense of space is revealed. This composition was later simplified by Pieter Bruegel the Younger; a specimen of the new version, already mentioned in 1614, is in the L. Joly Collection in Brussels. (See also plates 20–3.)

Plate 20

THE BATTLE BETWEEN CARNI-VAL AND LENT, detail. Lower half of the left-hand side.

Plate 38

"DULLE GRIET" or MAD MEG, detail. Infernal globe and lantern.

Plate 39

"DULLE GRIET" or MAD MEG, detail. The Entrance to Hell (detail).

Plates 40 and 41

THE TRIUMPH OF DEATH. *Tempera on panel, 117 × 162 cms. Madrid, Prado Museum.* Approximately 1562 (?). Already mentioned by van Mander, the painting is referred to in 1774 in the inventory of the Palacio San Ildefonso of Madrid, and entered the Prado in 1827. But in 1614 it is already mentioned, apparently, in the inventory of the Philips van Valckenisse Collection at Antwerp. Copies by Pieter Bruegel the Younger are in Graz and in the Liechtenstein Gallery. A Dantesque vision, whose terrifying impact is similar to that of "*Dulle Griet*", but here the composition is far superior. (See also plates 42 and 43.)

Plate 42

THE TRIUMPH OF DEATH, detail. Lower part on the left.

Plate 43

THE TRIUMPH OF DEATH, detail. Lower part on the right.

Plate 44

THE FALL OF THE REBEL ANGELS. *Tempera on panel, 117 × 162 cms. Brussels, Musées Royaux des Beaux-Arts de Belgique.* Acquired in 1846 in Brussels by F. Stappaerts. Signed and dated 1562. Elements of Flemish tradition and others derived from Hieronymus Bosch are fused in this work with some audaciously personal features. The fight of the Angels is further stressed by skilful contrasts of color. (See also plates 45 and 46.)

Plate 45

THE FALL OF THE REBEL ANGELS, detail. The angels are transformed into diabolic monsters.

Plate 46

THE FALL OF THE REBEL ANGELS, detail. The Archangel Michael.

Plate 47

TWO MONKEYS. *Tempera on panel, 20 × 23 cms. Berlin, Staatliche Museen.* Acquired in 1930 in Paris via the trade from a Russian collection. Signed and dated 1562. A simple subject, but absolutely new for the time. The admirable panoramic view in the background, all in tones of blue of extreme delicacy, portrays the harbor of Antwerp and the surrounding countryside.

Plate 48

THE SUICIDE OF SAUL, or THE BATTLE OF GELBOE. *Tempera on panel, 33·5 × 55 cms. Vienna, Kunsthistorisches Museum.* Signed and dated 1562 (?). The inscription on the panel reads: "Saul, xxxi capit." The work is quoted by Chrétien de Mechel in the catalogue mentioned in the description of plates 24-25. The painter uses this uncommon Biblical subject (First Book of Samuel, xxxi, 4) as a means of portraying his memories of his journey through the Alps: the Jews and Philistines, in spite of their great numbers, appear insignificant compared with the grandeur of the mountains. (See also plates 49 and 50.)

Plate 49

THE SUICIDE OF SAUL, or THE BATTLE OF GELBOE, detail of the landscape.

Plate 50

THE SUICIDE OF SAUL, or THE BATTLE OF GELBOE, detail. The death of Saul.

Plate 51

THE TOWER OF BABEL. *Tempera on panel, 114 × 155 cms. Vienna, Kunsthistorisches Museum.* Signed and dated 1563. According to van Mander, this work was in the collections of Emperor Rudolf II; it was mentioned successively in two inventories of the sixteenth century and in that for the gallery of Archduke Leopold Wilhelm of Austria in 1659; and quoted finally in the catalogue of Chrétien de Mechel. It is not known to which version—this one or the one described further on —the inventories and catalogue refer. Van Mander speaks explicitly of the "great" and of the "small" *Tower of Babel.* According to the Bible (Genesis xi, 1–9), the tower proved to be Utopia: it subsides, crumbles, and is on the point of falling down; a host of small figures is busily working inside and all round the huge edifice without, however, reducing in the least the impression of gigantic size created by the building. The passages of color in the walls of the tower itself, from bronze-green to rosy brown, stand out strongly against the green of the landscape and the blue of the sky. (See also plates 52–6.)

Plate 52

THE TOWER OF BABEL (*Vienna*), detail. The Royal procession.

Plate 53

THE TOWER OF BABEL (*Vienna*), detail. Laborers at work.

Plate 54

THE TOWER OF BABEL (*Vienna*), detail. Carts at the foot of the Tower.

Plate 55

THE TOWER OF BABEL (*Vienna*), detail of the construction.

Plate 56

THE TOWER OF BABEL (*Vienna*), detail of the construction.

Plate 57

THE TOWER OF BABEL. *Tempera on panel, 60 × 74·5 cms. Rotterdam, D. C. van Beuningen Collection.* The approximate date—as for the Vienna *Tower of Babel,* which it resembles very much—is 1563 (?). On the reverse of the panel are the arms of Queen Elisabeth of Valois, wife of Philip II. (See also plates 58 and 59.)

Plate 58

THE TOWER OF BABEL (*Rotterdam*), detail of the construction.

Plate 59

THE TOWER OF BABEL (*Rotterdam*), detail. Ships at anchor.

Plate 60

HEAD OF AN OLD PEASANT WOMAN. *Tempera on panel, 22 × 18 cms. Munich, Alte Pinakothek.* Approximately 1563 (?). This caricature-like head of exceptional vigor was housed in the Castle of Neuburg, on the Danube, and then in the Nuremburg Museum from whence it passed to Munich in 1912. Although it is a unique example in the catalogue of Bruegel's extant works, quite a few head studies seem to have been made by the master. (See Lost Paintings.)

Plate 61

THE ADORATION OF THE MAGI. *Tempera on panel, 108 × 83 cms. London, National Gallery.* Signed and dated 1564. It is perhaps the only work in which the painter reveals some Italian influences and recalls the genre of the *sacre conversazioni*. In 1890 the painting was in a Viennese private collection. From here it was transferred in 1900 to the G. Roth Collection, though remaining in Vienna. Then in 1921 it was sold to the National Gallery. Copies by Jan Bruegel are kept in the Museums of Vienna, Antwerp and London. (See also plates 62–5.)

Plate 62

THE ADORATION OF THE MAGI, detail. The entourage of the Magi.

Plate 63

THE ADORATION OF THE MAGI, detail. A soldier.

Plate 64

THE ADORATION OF THE MAGI, detail. St Joseph, Gaspar and others.

Plate 65

THE ADORATION OF THE MAGI, detail. Melchior and Balthazar adoring the Child in the arms of the Virgin.

Plate 66

THE ROAD TO CALVARY. *Tempera on panel, 124 × 170 cms. Vienna, Kunsthistorisches Museum.* Signed and dated 1564. According to van Mander, the panel belonged to Emperor Rudolf II; it reappears in 1768 in the inventory of the *Geistliche Schatzkammer* of Vienna, before appearing in the catalogue of Chrétien de Mechel. This is a subject that the master must have treated frequently because paintings under this title are mentioned in several inventories of the sixteenth and seventeenth centuries. In this vast landscape, the composition of which draws the eye towards the summit of Golgotha, the artist has gathered more than 500 characters; the group of holy women and St John does not share in the style already so typically Bruegelian of the whole, and is much more traditional. (See also plates 67–70.)

Plate 67

THE ROAD TO CALVARY, detail. Jesus falls under the weight of the cross.

Plate 68

THE ROAD TO CALVARY, detail. The thieves are led to their place of punishment.

Plate 69

THE ROAD TO CALVARY, detail. The Cyrenian helps Jesus to carry His cross.

Plate 70

THE ROAD TO CALVARY, detail. Golgotha.

Plate 71

THE DEATH OF THE VIRGIN. *Tempera in grisaille, 36 × 54·5 cms. Richmond, Collection of Viscount Lee of Fareham.* Acquired in 1930 in London from the trade. Signed: date no longer legible; perhaps around 1564 (?). This composition is so surprising for the period that its authenticity has been discussed. However, the inventory of the paintings in the possession of Peter Paul Rubens—made after his death in 1640—is very precise about it: "The death of Our Lady, white and

black, by Bruegel the Elder." It is, perhaps, the same painting mentioned later in the inventory of Jan-Baptista Anthoine, Antwerp, 1691. This monochrome, however, unique in the present catalogue of Bruegel's works, was painted for the famous geographer, Ortelius.

Plates 72 and 73

THE STORMY DAY. *Tempera on panel, 118 × 163 cms. Vienna, Kunsthistorisches Museum.* Signed and dated 1565. This painting is supposed to illustrate March in the celebrated series of the "Months". Because of the gloomy sky, the dark clouds and the impression of wind, the landscape is reminiscent of the usual atmosphere of Flanders. According to the inventory of 1659, the painting is supposed to have been in the collections of the Archduke Leopold Wilhelm of Austria, together with the four following works. The complete series of the twelve "Months" was probably commissioned and bought by Nicolaas Jongelinck of Antwerp, because already in 1565—the year in which Bruegel executed the whole series— he mentions it in an agreement with the local authorities. (See also plates 74–7.)

Plate 74

THE STORMY DAY, detail of the background on the left.

Plate 75

THE STORMY DAY, detail. The village on the left.

Plate 76

THE STORMY DAY, detail of the center background.

Plate 77

THE STORMY DAY, detail. Seascape.

Plate 78

THE CORN HARVEST. *Tempera on panel, 117 × 160 cms. New York, Metropolitan Museum.* Signed, but the date is only partly legible: 1565. After 1659 (see *The Stormy Day*) this work is mentioned again in the catalogue of Chrétien de Mechel. It seems certain that it was stolen from the Belvedere of Vienna by the French Imperial armies in 1809; P.-J. Cels, of Brussels, bought it from J. Doucet in Paris, and a little later, in 1912, sold it to the Metropolitan Museum. In the cycle of the "Months", the painting is supposed to represent the labors of August: the coloring evokes with great suggestive power the stifling heat of the summer. (See also plates 79–83.)

Plate 79

THE CORN HARVEST, detail. The meal of the harvesters.

Plate 80

THE CORN HARVEST, detail. The harvesters at work.

Plate 81

THE CORN HARVEST, detail. Woman harvesting.

Plate 82

THE CORN HARVEST, detail. Harvesters among the corn.

Plate 83

THE CORN HARVEST, detail. Harvester in repose.

Plate 84

THE RETURN OF THE HERD. *Tempera on panel, 117 × 159 cms. Vienna, Kunsthistorisches Museum.* Signed and dated 1565. This painting represents November in the series of the "Months". In spite of the bad

state of preservation, the painting is striking for the power of the composition and the harmony of the colors, bluish-green and light brown. (See also plates 85–7.)

Plate 85

THE RETURN OF THE HERD, detail. A shepherd.

Plate 86

THE RETURN OF THE HERD, detail. Another shepherd.

Plate 87

THE RETURN OF THE HERD, detail. Another shepherd.

Plates 88 and 89

THE HUNTERS IN THE SNOW. *Tempera on panel, 117 × 162 cms. Vienna, Kunsthistorisches Museum.* Signed and dated 1565. Mentioned in the inventory of 1659 (see *The Stormy Day*) as well as in the catalogue of Chrétien de Mechel. The magnificent condition of this panel, which in the series of the "Months" illustrates the importance of hunting in February, gives the full measure of Pieter Bruegel's art, which is so rich in delicate shades; the extremely subtle range of grays makes this painting, perhaps, the purest and most unforgettable masterpiece by Bruegel. (See also plates 90–4.)

Plate 90

THE HUNTERS IN THE SNOW, detail. A huntsman.

Plate 91

THE HUNTERS IN THE SNOW, detail. Peasants singeing the bristles of a slaughtered pig.

Plate 92

THE HUNTERS IN THE SNOW, detail of the center background.

Plate 93

THE HUNTERS IN THE SNOW, detail. The village bridge.

Plate 94

THE HUNTERS IN THE SNOW, detail. Landscape in the background.

Plate 95

WINTER LANDSCAPE. *Tempera on panel, 38 × 56 cms. Brussels, Collection of Dr F. Delporte.* Signed and dated 1565. A delightful little painting which belongs to the same conception as the "Months", though being of a more meticulous technique. The original panel is quoted in the inventory of the goods of H. Meyeringh, art merchant of Amsterdam, in 1687. Numerous copies—some by Pieter Bruegel the Younger—are in the Prado Museum, the Vienna Museum, etc. This painting was a great revelation at the Flemish and Belgian Art Exhibition held in London in 1927. (See also plates 96 and 97.)

Plate 96

WINTER LANDSCAPE, detail. Village under the snow.

Plate 97

WINTER LANDSCAPE, detail. Bushes.

Plate 98

THE HAY HARVEST. *Tempera on panel, 114 × 158 cms. Raudnitz (Bohemia).* Once in the Collection of the Prince of Lobkovitz. False signature. Date approximately 1565 (?). This panel is also included in the inventory of 1659 (see *The Stormy*

Day). These activities of June fit very well into the powerful series of the "Months". One finds the same ardent and ingenuous love of nature and the same subtlety in the use of color for the rendering of light. (See also plates 99–101.)

Plate 99

THE HAY HARVEST, detail. Peasants carrying baskets with fruit.

Plate 100

THE HAY HARVEST, detail. Haywain.

Plate 101

THE HAY HARVEST, detail. Three women harvesters.

Plate 102

PEASANTS DANCING BEFORE THE INN. *Tempera on panel, 75 × 105 cms. Lugano, Schloss Rohoncz Collection. c.* 1565 (?). Attribution sometimes contested. (See also plate 103.)

Plate 103

PEASANTS DANCING BEFORE THE INN, detail of the dancers.

Plates 104 and 105

THE WEDDING PROCESSION. *Tempera on panel, 67·5 × 120 cms. Northwick Park (Gloucestershire), Spencer Churchill Collection.* Approximately 1565 (?). All evidence leads to the conclusion that this work was the first of a new series devoted to weddings and village festivities based on reality.

Plate 106

THE WEDDING DANCE IN THE OPEN AIR. *Tempera on panel, 119 × 157 cms. Detroit, Institute of Arts.* Acquired in England from the trade in 1930. Unsigned, but dated 1566. This painting seems outstanding among the many inspired by the same theme. The color—it was cleaned in 1942—is so thin that you can easily see under it the first preparatory drawing of the figures, which the artist made to suggest the movement of the dance. (See also plates 107–9.)

Plate 107

THE WEDDING DANCE IN THE OPEN AIR, detail. Dancers in the foreground.

Plate 108

THE WEDDING DANCE IN THE OPEN AIR, detail. Dancers in the background.

Plate 109

THE WEDDING DANCE IN THE OPEN AIR, detail. Dancers and musicians on the right.

Plate 110

ST JOHN THE BAPTIST PREACH-ING. *Tempera on panel, 95 × 160·5 cms. Budapest Museum of Fine Arts.* Bequest of Count Ivan Batthyány. Signed and dated 1566. Vigorous technique, but composition perhaps less successful than in other works of the same period. Some museums possess replicas, made at different times, of this painting which is, above all, an admirable crowd study; numerous copies executed by the painter's sons are in the Pinakothek of Munich, at the Liechenstein Gallery, etc. (See also plates 111–13.)

Plate 111

ST JOHN THE BAPTIST PREACH-ING, detail. Some listeners in the top left-hand side.

Plate 112

ST JOHN THE BAPTIST PREACH-
ING, detail. St John the Baptist.

Plate 113

ST JOHN THE BAPTIST PREACH-
ING, detail. Some listeners.

Plate 114

THE NUMBERING OF THE PEOPLE
AT BETHLEHEM. *Tempera on panel,
117 × 164·5 cms. Brussels, Musées
Royaux des Beaux-Arts de Belgique.*
Acquired in 1902 at the Huybrechts
sale in Antwerp. Previously in the
Van Colen de Bouchout Collection
in Antwerp. Signed and dated 1566.
The painting neglects the religious
side of the subject (the census
decreed by Augustus: Gospel of
St Luke, ii); the Virgin and St
Joseph are almost hidden in the
midst of a crowd. The small, snow-
covered village, typical of the
Brabant, seen at sunset on a cold and
clear December day is, instead,
rendered with surprising skillfulness,
the inn on the left is called *In de
groene Kroon* ("At the sign of the
Green Wreath"); a sign hanging in
front of the inn carries the coat of
arms of Charles V. There are
numerous copies, particularly by
Pieter Bruegel the Younger. (See also
plates 115–21.)

Plate 115

THE NUMBERING OF THE PEOPLE
AT BETHLEHEM, detail. The killing
of the boar.

Plate 116

THE NUMBERING OF THE PEOPLE
AT BETHLEHEM, detail of the
background on the left.

Plate 117

THE NUMBERING OF THE PEOPLE
AT BETHLEHEM, detail of the
background on the right.

Plate 118

THE NUMBERING OF THE PEOPLE
AT BETHLEHEM, detail. The people
presenting themselves for the census-
taking.

Plate 119

THE NUMBERING OF THE PEOPLE
AT BETHLEHEM, detail. The frozen
pond.

Plate 120

THE NUMBERING OF THE PEOPLE
AT BETHLEHEM, detail. The count-
ing of the coins.

Plate 121

THE NUMBERING OF THE PEOPLE
AT BETHLEHEM, detail. The Virgin
on the little donkey.

Plate 122

THE MASSACRE OF THE INNO-
CENTS. *Tempera on panel, 111 × 160
cms. Vienna, Kunsthistorisches Museum.*
Signed, *c.* 1566 (?). This painting
seems to have been conceived as a
"pendant" to the previous one to
which it is, nevertheless, inferior.
So much so, that very often there
have been doubts as to its authen-
ticity. The subject has been men-
tioned by van Mander; the painting
belonged to Emperor Rudolf II and
figured, in 1748, in the inventory of
the *Geistliche Schatzkammer* of Vienna.
There are numerous copies, parti-
cularly by Pieter Bruegel the
Younger. (See also plates 123–5.)

Plate 123

THE MASSACRE OF THE INNO-
CENTS, central detail.

Plate 124

THE MASSACRE OF THE INNOCENTS, detail. Soldiers.

Plate 125

THE MASSACRE OF THE INNOCENTS, detail. A soldier and a mother.

Plate 126

THE LAND OF COCKAYNE. *Tempera on panel, 52 × 78 cms. Munich, Alte Pinakothek.* This painting is mentioned in the inventories of the imperial collections of Prague up to the sack of the city in 1648. Obviously stolen by some unknown person, it reappeared in a French collection in 1901. The Pinakothek of Munich bought it in 1917 from the Von Kaufmann Gallery in Berlin. Signed and dated 1567. An excellent work, beautifully preserved and magnificently representative of the art and technique of Bruegel. (See also plates 127–31.)

Plate 127

THE LAND OF COCKAYNE, detail. The soldier resting.

Plate 128

THE LAND OF COCKAYNE, detail. The peasant resting.

Color Plate III

THE CONVERSION OF ST PAUL. (See also plates 132–5.)

Plate 129

THE LAND OF COCKAYNE, detail. The scholar resting.

Plate 130

THE LAND OF COCKAYNE, detail. The table.

Plate 131

THE LAND OF COCKAYNE, detail. The pig and the cake.

Plate 132

THE CONVERSION OF ST PAUL. *Tempera on panel, 108 × 156 cms. Vienna, Kunsthistorisches Museum.* Signed and dated 1567. According to van Mander, it belonged to Emperor Rudolf II. The religious theme is, by now, only a pretext, as in *The Numbering of the People at Bethlehem*, but this work particularly recalls *The Suicide of Saul* because of its memories of Alpine landscapes and grandeur of effects. It seems to have been inspired by a drawing executed by Bruegel during his journey to Italy and now in the Louvre under the number 19,737. (See also plates 133–5.)

Plate 133

THE CONVERSION OF ST PAUL, detail. Saul is thrown from his horse.

Plate 134

THE CONVERSION OF ST PAUL, detail. A warrior.

Plate 135

THE CONVERSION OF ST PAUL, detail. A warrior.

Plate 136

THE ADORATION OF THE MAGI. *Tempera on panel, 35 × 55 cms. O. Reinhart Collection.* Signed and dated, though not very legibly, 1567. Not all by the hand of the master? Numerous copies, particularly by Pieter Bruegel the Younger. (See also plate 137.)

Plate 137

THE ADORATION OF THE MAGI, detail of the background.

Plate 138

THE PARABLE OF THE BLIND. *Tempera on canvas, 86 × 154 cms. Naples, Gallerie Nazionale di Capodimonte.* Once in the Palazzo del Giardino of Parma. Signed and dated 1568. Theme inspired by the Gospel (St Matthew, xv, 14 and St Luke, vi, 39): ". . . and if the blind lead the blind both shall fall into the ditch." The great diagonal line of the composition accentuates the fall of these unhappy people, whose misfortune is stressed even more by the contrast of the fascinating, spring-like and serene landscape. An inventory made in Mantua in 1627 mentions this work but speaks of only four blind men instead of six. Several copies exist—at the Louvre, at the Pinacoteca of Parma, at the Liechtenstein Gallery, etc.— generally by Pieter Bruegel the Younger. (See also plates 139–42, and color plate I.)

Plate 139

THE PARABLE OF THE BLIND, detail. The fall of the first two blind men.

Plate 140

THE PARABLE OF THE BLIND, detail. Head of a blind man.

Plate 141

THE PARABLE OF THE BLIND, detail. Head of a blind man.

Plate 142

THE PARABLE OF THE BLIND, detail. Landscape in the background on the right.

Plate 143

THE MISANTHROPE. *Tempera on canvas, 86 × 85 cms. Naples, Gallerie Nazionale di Capodimonte.* Signed and dated 1568. The painting was noted in the house of Count G. B. Masi at Parma a few years before its confiscation by the Farnese family in 1611; in 1680 it reappeared in the inventory of the Palazzo del Giardino, still in Parma, and in the eighteenth century it is to be found in Naples. The inscription in old Flemish reads: "Because the world is so unfaithful I wear mourning." The young urchin who is cutting the purse of the old man seems to be a later addition: he mars the quietness of the landscape, disturbs the bitter meditations of the wanderer, and the figure's pictorial quality is clearly inferior. An authentic masterpiece, in which Bruegel's great love for his own country is very evident.

Plate 144

THE CRIPPLES. *Tempera on panel, 18 × 21 cms. Paris, Louvre.* Signed and dated 1568. As in *The Parable of the Blind*, we have here a powerful contrast between the deformed and clumsy bodies and the radiant landscape in the background. The foxtails on the clothing of the figures (as in the similar characters of *The Battle between Carnival and Lent*) were the emblem of the beggar before it became that of the Huguenot party of the *Gueux* (Beggars). The painting seems to have been taken away from Prague in 1648 by the Swedes; it is mentioned in the list of the paintings belonging to Queen Christine drawn up in 1652 by the Marquis of Fresne. In 1892 it was given to the Louvre by the art-critic, Paul Mantz. The same subject, treated by Bruegel, appears in three different collections of Antwerp in the seventeenth century.

Color Plate IV

PEASANT WEDDING. (See also plates 150-3.)

Plate 145

THE ROBBER OF THE BIRD'S NEST. *Tempera on panel, 59 × 68 cms. Vienna, Kunsthistorisches Museum.* Signed and dated 1568. An illustration of the old Flemish saying, "He who knows where the nest is has only the knowledge; he who steals it has the nest." The young peasant in the foreground pointing to the boy stealing the nest is about to fall into the river. The landscape on the right is the best part of the painting, but has been cleaned too often. In the inventory of the Archduke Leopold Wilhelm of Austria (1659) the work is attributed to Pieter Bruegel the Younger; Chrétien de Mechel mentions it in his catalogue. Transferred to France in 1809 by the Napoleonic Army, it returned to Vienna in 1815. (See also plates 146-8.)

Plate 146

THE ROBBER OF THE BIRD'S NEST, detail of the trees.

Plate 147

THE ROBBER OF THE BIRD'S NEST, detail. Head of the peasant boy.

Plate 148

THE ROBBER OF THE BIRD'S NEST, detail. The little thief.

Plate 149

THE MERRY WAY TO THE GALLOWS. *Tempera on panel, 46 × 51 cms. Darmstadt, Landesmuseum.* Previously in the collection of the Grand Dukes of Hesse. Signed and dated 1568. A work in which the landscape is absolutely dominant.

Plate 150

PEASANT WEDDING. *Tempera on panel, 114 × 163 cms. Vienna, Kunsthistorisches Museum.* Approximately 1568. The lower part of the painting was subsequently enlarged. It serves as a testimony to the freedom of treatment attained by Bruegel towards the end of his life. He is here revealed as a supreme portrayer of country life. (See also plates 151-3.)

Plate 151

PEASANT WEDDING, detail. The bride.

Plate 152

PEASANT WEDDING, detail. Wine jars.

Plate 153

PEASANT WEDDING, detail. Musicians.

Plate 154

PEASANT DANCE, or "KERMESSE". *Tempera on panel, 114 × 164 cms. Vienna, Kunsthistorisches Museum.* Previously in the *Weltliche Schatzkammer.* Signed, but not dated; approximately 1568 (?). This work has some affinity with the previous ones, but it is realized in an even more synthetic style; the painter portrays only a few particularly suggestive types, and displays an absolute mastery in the rendering of motion. Mentioned in the catalogue of Chrétien de Mechel, who considers it a "pendant" to *Peasant Wedding.* (See also plates 155-7.)

Plate 155

PEASANT DANCE, or "KERMESSE", detail. Musician and drinker.

Plate 156

PEASANT DANCE, or "KERMESSE", detail. Head of a dancing woman.

Plate 157

PEASANT DANCE, or "KERMESSE", detail. Head of a dancing man.

Plate 158

STORM AT SEA. *Tempera on panel, 70·5 × 97 cms. Vienna, Kunsthistorisches Museum,* where it was transferred in 1880 from the Belvedere. Approximately 1568 (?). It is perhaps the master's last work, he reveals in it the same sureness of touch as in the "Months". (See also plates 159 and 160.)

Plate 159

STORM AT SEA, detail. The whale.

Plate 160

STORM AT SEA, detail. A ship.

LOST PAINTINGS

The works whose titles are not followed in this book by further explanations are mentioned in the old sources: Schilderboek, *by C. van Mander (1604);* Catalogus, *by G. Hoet (c. 1700) and the inventories of Giulio Clovio (Rome, 1557), the house of de Granvelle (Besançon, 1607), Philips van Valckenisse (Antwerp, 1614), Nicolaes Cornelis Cheeus (Antwerp, 1621), Jacques Snel (Antwerp, 1623), Antoinette Wiael (Antwerp, 1627), Carel de la Fossa (Antwerp, 1634), Peter Paul Rubens (Antwerp, 1640), Nicolaas Rockox (Antwerp, 1640), Herman de Neyt (Antwerp, 1642), Sara Schut in van Can, the widow Nielis (Antwerp, 1644), Cornelis Schut (Antwerp, 1645), Abraham Matthys (Antwerp, 1649), Jan van Meurs (Antwerp, 1652), Jeremias Wildens (Antwerp, 1653), Anna de Smidt-Fraryn (Antwerp, 1655), Susanna Willemsens, the widow van Borm (Antwerp, 1657), Maria de Bodt, the widow Kordaens (Antwerp, 1659), Anna Colyns, the widow Diriexen (Antwerp, 1667), Jan-Baptista Borrekens (Antwerp, 1668), Peter Stevens (Antwerp, 1668), Peter Wynants (Antwerp, 1669), Jaspar van Havre (Antwerp, 1669), Hendrick Bartels (Antwerp, 1672), Erasme Quellin (Antwerp, 1678), Diego Duarte (Antwerp, 1682), Alexander Voet (Antwerp, 1685 and 1689), Jan-Baptista Anthoine (Antwerp, 1691), Cornelis Dusart (The Hague, 1704). The same sources also hint at some other paintings by Bruegel on unspecified subjects.*

A—PAINTINGS WITH RELIGIOUS SUBJECTS

THE STORY OF JONAH.

THE VIRGIN IN A LANDSCAPE.

THE FLIGHT INTO EGYPT.

THE TEMPTATION OF JESUS.

THE UNFAITHFUL SHEPHERD (*a copy is in the Johnson Collection of Philadelphia.* (See Attributed Paintings.)

JESUS AND THE WOMAN TAKEN IN ADULTERY (reproduced in an engraving by Petrus Perret and in numerous copies; the original seems to have been a monochrome painting of 1565); Ecce homo.

CRUCIFIXION (*copies in the museums of Berlin, Budapest and Philadelphia*).

FACE OF CHRIST.

RESURRECTION (engraved by Cock).

BATTLE BETWEEN TURKS AND CHRISTIANS (to be identified, perhaps, with *The Suicide of Saul*, in the Vienna Museum).

THE TRIUMPH OF TRUTH.

HELL.

B—PAINTINGS WITH SECULAR SUBJECTS

THE FOUR ELEMENTS.

THE MONTH OF AUGUST.

THE REMEDIES AGAINST DEATH.

THE EXTRACTION OF THE PHILOSOPHER'S STONE (reproduced in a copper engraving; *copies in the museum of Saint-Omer and in private collections*. (See Attributed Paintings.)

ICE-SKATING SCENE IN FRONT OF THE ST GEORGE GATE IN ANTWERP (reproduced in an engraving by Frans Huys published by Cock; the original belonged to a series of four paintings illustrating the pastimes of the various seasons, two of which are still in existence— *The Battle between Carnival and Lent* and *Children's Games*, representing spring and summer, *both in the Vienna Museum*).

THE "KERMESSE" OF HOBOKEN (reproduced in an engraving by B. de Momper; illustrating autumn in the same series).

"KERMESSE" IN THE COUNTRY-SIDE.

WEDDING DANCE IN THE OPEN (engraving by P. van der Heyden published by Cock; *copies in the Borchard Collection of New York, the Munich Pinakothek, the Narbonne Museum*, etc.).

WEDDING DANCE INDOORS (copies by Pieter Bruegel the Younger and by his imitators *in the Johnson Collection of Philadelphia* (see Attributed Paintings), *in the Stockholm Museum, in the National Gallery of Dublin*, etc.)

THE BLIND MAN AND THE BRIDE.

WEDDING PROCESSION TO THE CHURCH.

PEASANT WEDDING.

BANQUET IN THE COUNTRY.

THE DRINKERS.

THE VISIT TO THE WET-NURSE (copies by Jan Bruegel *in the museums of Vienna, Antwerp*, etc.).

PEASANTS ATTACKED (*copies in the University of Stockholm and in the Liechtenstein Gallery*).

QUARREL AMONGST PLAYERS (*copies by Jan Bruegel in the Vienna Museum, and by Pieter Bruegel the Younger in the Montpellier Museum*, etc.).

TWO "GENRE SCENES".

C—PORTRAITS AND HEADS

PORTRAIT OF AN UNKNOWN MAN.

PORTRAITS OF FRANS FLORIS AND HIS WIFE.

PORTRAIT OF PIETER COECKE'S WIFE.

SELF-PORTRAIT (?).

A BLIND MAN.

TWO "HEADS" (*tondi*—round wooden panels).

A YAWNING FIGURE (reproduced in an engraving by L. Vorsterman; *copy by Pieter Bruegel the Younger in the Meier Collection of Carlsbad*).

A BEGGAR (*tondo*).

TWO "FEMININE HEADS" (*tondi*).

VARIOUS OTHER UNIDENTIFIED "HEADS".

D—LANDSCAPES AND SEASCAPES

VIEW OF A MOOR.

LANDSCAPE WITH TREE.

WINTER.

MOUNT SAN GOTTARDO.

LANDSCAPE WITH FIRE.

TREES IN THE NIGHT.

VARIOUS OTHER "LANDSCAPES".

VARIOUS "BOATS".

PAINTINGS ATTRIBUTED TO BRUEGEL

(We quote here only the works that are still the object of controversy by the most authoritative modern critics)

WEDDING DANCE INDOORS. *Philadelphia, Johnson Collection.* (See Lost Paintings.) Attribution by G. Hulin de Loo, W. R. Valentiner and G. Glück.

WEDDING DANCE. *Antwerp Museum.* Attribution by G. Hulin de Loo and E. Michel.

TWO PEASANTS MAKING FAGGOTS. *Belgrade.* Previously in the Collection of Prince-Regent Paul. Attribution by M. J. Friedländer.

THE BATTLE BETWEEN CARNIVAL AND LENT. *Copenhagen Museum.* A copy of the painting reproduced in plate 19? Attribution by G. Hulin de Loo.

THE UNFAITHFUL SHEPHERD. *Philadelphia, Johnson Collection.* (See Lost Paintings.) Attribution by G. Hulin de Loo, E. Michel and G. Glück.

CHRIST DRIVING THE MONEY-CHANGERS OUT OF THE TEMPLE. *Copenhagen Museum.* Attribution by M. J. Friedländer, E. Michel and G. Glück.

THE FALL OF ICARUS. *Paris, Herbrand Collection.* A copy of the painting reproduced in plate 9? Attribution by G. Glück.

THE TEMPTATION OF ST ANTHONY. *New York, precise location uncertain.* Attribution by M. J. Friedländer and G. Glück.

THE EXTRACTION OF THE PHILOSOPHER'S STONE. *Budapest, precise location uncertain.* Painting with a signature similar to that of Bruegel, but not authentic, and the date 1556. Attribution by G. Hulin de Loo, M. H. Friedländer and G. Glück.

STILL LIFE WITH HERRINGS. *Harlem, Koenigs Bequest.* Attribution by G. Hulin de Loo and M. J. Friedländer.

RIVER LANDSCAPE WITH SOWER. *Madrid, Prado Museum.* A copy of the painting reproduced in plate 2? Attribution by E. Michel.

RIVER LANDSCAPE WITH SOWER. *Paris, Galerie Manteau.* Another copy of the painting reproduced in plate 2? Attribution by G. Glück.

HEAD OF A LANSQUENET. *Montpellier, Fabre Museum.* Attribution by G. Hulin de Loo.

45

LOCATION OF PAINTINGS

ANTWERP

MAYER VAN DEN BERGH MUSEUM

Twelve Proverbs (plates 4, 5, 6, 7). *"Dulle Griet"* or *Mad Meg* (plates 31, 32, 33, 34, 35, 36, 37, 38, 39).

STUYCK DEL BRUYERE COLLECTION

River Landscape with Peasant Sowing (plate 2).

BERLIN

STAATLICHE MUSEEN

The Netherlandish Proverbs (plates 12, 13, 14, 15, 16, 17, 18). *Two Monkeys* (plate 47).

BRUSSELS

MUSÉES ROYAUX DES BEAUX-ARTS DE BELGIQUE

The Adoration of the Magi (plate 3). *Landscape with the Fall of Icarus* (plates 9, 10). *The Fall of the Rebel Angels* (plates 44, 45, 46). *The Numbering of the People at Bethlehem* (plates 114, 115, 116, 117, 118, 119, 120, 121).

DELPORTE COLLECTION

Winter Landscape (plates 95, 96, 97).

BUDAPEST

MUSEUM

St John the Baptist Preaching (plates 110, 111, 112, 113).

DARMSTADT

LANDESMUSEUM

The Merry Way to the Gallows (plate 149).

DETROIT

INSTITUTE OF ARTS

The Wedding Dance in the Open Air (plates 106, 107, 108, 109).

EINDHOVEN

PHILIPS COLLECTION

The Archangel Michael (plate 1).

LONDON

THE NATIONAL GALLERY

The Adoration of the Magi (plates 61, 62, 63, 64, 65).

LUGANO

SCHLOSS ROHONCZ COLLECTION

Peasants Dancing before the Inn (plates 102, 103).

MADRID

PRADO MUSEUM

The Triumph of Death (plates 40–3).

MUNICH

ALTE PINAKOTHEK

Head of an Old Peasant Woman (plate 60). *The Land of Cockayne* (plates 126, 127, 128, 129, 130, 131).

NAPLES

GALLERIE NAZIONALE DI CAPODIMONTE

The Parable of the Blind (plates 138, 139, 140, 141, 142, and color plate I).
The Misanthrope (plate 143).

NEW YORK

METROPOLITAN MUSEUM OF ARTS

The Corn Harvest (plates 78, 79, 80, 81, 82, 83).

NORTHWICK PARK (GLOUCESTERSHIRE)

CHURCHILL COLLECTION

The Wedding Procession (plates 104–5).

PARIS

THE LOUVRE

The Cripples (plate 144).

RAUDNITZ (BOHEMIA)

(Formerly the LOBKOVITZ COLLECTION.

The Hay Harvest (plates 98, 99, 100, 101).

RICHMOND (YORK)

VISCOUNT LEE OF FAREHAM COLLECTION

The Death of the Virgin (plate 71).

ROME

GALLERIA DORIA
The Harbor at Naples (plate 8).

ROTTERDAM

BOYMANS MUSEUM, VAN BEUNINGEN COLLECTION

The Tower of Babel (plates 57, 58, 59).

VIENNA

KUNSTHISTORISCHES MUSEUM

The Wine of St Martin (plate 11).
The Battle between Carnival and Lent (plates 19, 20, 21, 22, 23).
Children's Games (plates 24–5, 26, 27, 28, 29, 30).
The Suicide of Saul (plates 48, 49, 50).
The Tower of Babel (plates 51, 52, 53, 54, 55, 56).
The Road to Calvary (plates 66, 67, 68, 69, 70).
The Stormy Day (plates 72–3, 74, 75, 76, 77).
The Return of the Herd (plates 84, 85, 86, 87).
The Hunters in the Snow (plates 88–9, 90, 91, 92, 93, 94, and color plate II).
The Massacre of the Innocents (plates 122, 123, 124, 125).
The Conversion of St Paul (plates 132, 133, 134, 135, and color plate III).
The Robber of the Bird's Nest (plates 145, 146, 147, 148).
Peasant Wedding (plates 150, 151, 152, 153, and color plate IV).
Peasant Dance (plates 154, 155, 156, 157).
Storm at Sea (plates 158, 159, 160).

WINTERTHUR

O. REINHART COLLECTION

The Adoration of the Magi (plates 136, 137).

SELECTED CRITICISM

Pieter Bruegel of Breda, a great imitator of the science and of the fantasies of Hieronymus Bosch, thereby acquiring the nickname of Hieronymus Bosch the Second.

M. L. GUICCIARDINI
Descrittione di tutti i Paesi Bassi, altrimenti detti Germania Inferiore, 1567

Honor to you, Peter, as your work is honorable, since for the humorous inventions of your art, full of wit, in the manner of the old masters, you are no less worthy of fame and praise than any other artist.

D. LAMPSONIUS
Artistic Garland, 1572

Pieter Bruegel has become famous not only because of his burlesque and fantastic compositions, but also because of his landscapes in the grand manner. Some of these landscapes would not be disowned by Titian himself.

J.-P. MARIETTE
The A B C, 1734

Bruegel executed studies of those feasts, which he painted admirably in oil and in tempera. Born to paint this type of subject, he would be the supreme master in his field were it not for Teniers.

J.-B. DESCAMPS
The Lives of the Flemish, German and Dutch Painters, 1753

In times like ours which are justly proud of having restored to prominence such masters as Frans Hals, Adriaen Brouwer and Rembrandt, it is right that we should see in Pieter Bruegel an artist who was far above a mere preoccupation with the bizarre or surprising.

H. HYMANS
Pieter Bruegel the Elder, 1890-1

It is undoubtedly a mistake to see Bruegel simply as a follower of Bosch. . . . In Bosch we still find the medieval idea of the devil and the symbolization of the occult forces by which the life of man and nature are surrounded; in Bosch, in spite of his inexhaustible wealth of invention, the moralist is greater than the poet. Bruegel, however, is interested in the study and description of all aspects of life. He looks for and finds things that are extravagant and grotesque. He is barely interested in showing man as he ought to be; on the contrary, he represents him as he really is, with a kind of humorous violence, with his defects, his passions and his prejudices, leaving to the spectator the task of drawing a moral from what he paints.

. . . Never before in the whole history of art was the indivisible unity of natural existence felt and represented with such conviction. The melancholy of dying nature and the tempestuous signs of its awakening, the sweet intimacy of winter and the exuberant fecundity of harvest-time, the moods of the seasons, the thin, pale air of winter, the heavy air of the summer, so full of light, the poetry of evening, the lay of the land, the mountains and valleys, the fields and roads, the changing vegetation according to the seasons, the tranquil village and its inhabitants, their daily labors, their joys and their sorrows, all this is a single whole—nature, the process of life. It is clear, therefore, that the observation of nature, so penetrating in Bruegel, was derived in the last analysis from that same conception of life on which his new way of painting popular customs was based. He considered man as a product of nature, of the soil on which he lived and of the particular conditions of his surroundings and his society.

But nothing gives a truer sense of the artist's greatness than the audacity and speed of his evolution, which enabled him to reach the summit of his development in the space of a few years, drawing new conclusions for every work from this basic conception. This may be seen particularly well in the further elaboration of his principles of composition. This subjective point of view, from so high and far that everything in his paintings appeared to be on the same level, this looking down from

the top of the gallery of life on to the show going on below, was not sufficient where it was necessary to feel directly the impact on man of the forces of nature. It was further necessary that the spectator should himself be fascinated by these forces and that is why Bruegel, at this stage of his career (of *The Seasons*), transfers his center of interest to the landscape itself.

... Somewhere, some poor blind men (*The Parable of the Blind*) have been the victims of an accident. Nobody will pay any attention to them. At most one or more of their relatives will shed a tear: the life of nature and of men goes on, and it is simply as if a leaf had fallen from a tree. But the new thing is that so insignificant an occurrence, with such insignificant characters, should have become a representation of the whole of life. What seems to be a coincidence, an isolated happening, circumscribed by time and space, and without any historical consequences worth mentioning, becomes the image of an inescapable destiny to which humanity as a whole is blindly subjected.

M. DVORAK
A History of Art as a History of the Spirit, 1924

We discover a deep, wide and generous nature which has mastered the prodigious and secret art of rendering what is general, characteristic and durable, not through cold and conventional abstractions, but on the contrary by starting from the simplest and most genuine reality. This essential and dominating faculty Bruegel was to apply in good time to express, in a thousand different forms, one of the most original and typical points of view of his powerful personality: the smallness of man in front of nature, whether threatening, hostile or simply unfamiliar. When necessary, Bruegel could also show us man happily engulfed and lost in the fecundity of a luminous land, even if the human figure will always remain a detail in the vast general life whose greatness and force the painter portrays with supreme mastery.

... And Bruegel, as well as reflecting in his work a large part of life, at the same time and better than anybody before him

painted the true face of Flanders, of the Campine and its inhabitants.

<div align="right">E. MICHEL
Bruegel, 1931</div>

The whole world is revealed to us in his paintings, the world not of course as it should be but as it is. Bruegel describes more than he teaches; he makes a statement without pronouncing judgement; he renders pure reality without criticism but seen with the incomparable eye of an artist. He is never instructive and the term "didactic" applies to none of his paintings, however often it may have been used of them. On the other hand, he is no scoffer, but rather an observer, by no means indifferent to the emotions of life, to pain, strife, joy and mirth. But he himself neither weeps, laughs nor struggles. But a light, sorrowful smile may have sometimes lingered on his lips.

<div align="right">G. GLÜCK
The Paintings of Bruegel, 1934</div>

Hieronymus Bosch, born in the declining period of the medieval cosmic system, shows in his work the chasm which divides the secular world, which has become the prey of demons, from the Kingdom of God. Bruegel's aim is to eliminate the duality of creator and creature by refusing to admit the existence of any celestial form of entity. He achieves a synthesis of nature and of the human soul which from now on is endowed with its own vital principle.

<div align="right">C. DE TOLNAY
Pieter Bruegel the Elder, 1935</div>

Age had no effect on the art of Bruegel. Habits, mannerisms, formalism, none of these is detectable in any of his works. Instead, one ever finds new conceptions which seem to spring to life from rhythmic strokes of the brush. Bruegel often painted carelessly, with broad, violent brush strokes, but often too with minute attention and exactness.

. . . He can outline a scene from his infallible memory with snapshot precision, when necessary. The secret of this gift is due to the fact that a single glimpse leaves in his mind's eye a deep and unforgettable memory. He does not start from the nude, he

does not analyze every visual idea, nor does he look to any expression of foreign art: rather he imagines as a story teller and realizes as a draftsman.

. . . Bruegel is a master of the anecdotic genre. In reality . . . his presence is felt only on a superior level and, apart from Daumier, it would be impossible to find his rival.

M. J. FRIEDLÄNDER
The Ancient Painting of the Netherlands, 1937

Pieter Bruegel the Elder, heir to the spirit of Hieronymus Bosch, further amplifies the innovating tendencies of his predecessor. All through his vast production, so varied and brimming over with new ideas and lively colors, Bruegel undoubtedly appears as the prototype of the Flemish Renaissance artist, a period distinguished by a vast and universal though united vision of life.

. . . His mind, so full of curiosity, draws on everyday events to illustrate those innumerable proverbs which form a store of wisdom for country people, but his aim, beyond the mere recording of these scenes, is to achieve a deep understanding of the complexities of human nature.

J. LAVALLEYE
Flemish Painting and the Renaissance, 1939

. . . All this contributes to show how necessary it is, when trying to understand the intellectual meaning of Bruegel's work, to mistrust the art historians whose facility in writing too often hides a purely subjective attitude and a lack of the truly scientific spirit. Bruegel is not, therefore, the bizarre master he was once thought to be, neither is he a philosopher who, lost in transcendental considerations, seeks to give us the cosmic image of a topsy-turvy world. He is, and he wants to be, only a moralist, like Hieronymus Bosch before him and other artists of our country, although he rose—thanks to his wider learning—to a more humane and universal level. C. TERLINDEN
Pieter Bruegel the Elder and History, 1942

Besides a personal style, Bruegel created a world of his own, independent of ancient tradition and new trends. He did not,

even for a moment, think of the town hall or of the church, where his highly individual works would have appeared bizarre in the extreme, but of the most private rooms of the nobility and of the high dignitaries of state, where the beauties of his paintings could be enjoyed in solitude. This detachment from every type of tradition, this indifference to any social function, this decision to take into account only personal experiences and to address himself only to a well-defined minority, betray a modern outlook which is not to be found in such a high degree in any of the representatives of the Roman school in the Netherlands.

. . . If, in spite of everything, he is still considered one of the most popular artists of all times, it is because he seems to have taken part in the life of the common people and of the country-side as no other artist before him, and also because he succeeded in disclosing the essential nature of this world, thanks to a vision and to a style which, by unanimous consent, embody the constant and universal expression of the popular and peasant "genre".

A. STUBBE
Bruegel and the Renaissance, 1947

The interpretation of Bruegel, the man and the work, from his day to ours, presents a bewildering spectacle. The man has been thought to have been a peasant and a townsman, an orthodox Catholic and a libertine, a humanist, a laughing and a pessimistic philosopher; the artist appeared as a follower of Bosch and a continuator of the Flemish tradition, the last of the Primitives, a Mannerist in contact with Italian art, an illustrator, a "genre" painter, a landscape artist, a realist, a painter consciously trans-forming reality and adapting it to his formal ideal—the sum of just a few opinions expressed by various observers in the course of four hundred years. With the exception of the peasant, whom I think we can decently bury, each of these views, even when apparently contradicted by another, contains some part of the truth. The apparent contradictions mirror the different aspects of an inexhaustibly rich personality. F. GROSSMANN
Bruegel; The Paintings, 1955

BIBLIOGRAPHICAL NOTE

Mentions of Pieter Bruegel, other than in the *Schilderboek* or *Book of Painters*, by Carel van Mander (Harlem, 1604)—already quoted in the text—are already to be found in writers of the sixteenth and seventeenth centuries, i.e. L. Guicciardini (Antwerp, 1567), D. Lampsonius (Antwerp, 1572), C. de Bie (Amsterdam, 1661), J. von Sandrart (Nuremburg, 1675), I. Bullart (Paris, 1682), F. le Comte (Paris, 1699). In the following centuries the reputation of Bruegel remained lively enough, though limited to a minor aspect of his personality, as is proved by the judgements passed by (among others) A. Houbraken (Amsterdam, 1718), J.-B. Descamps (Paris, 1753), G. K. Nagler (Munich, 1835), J. Immerzeel (Amsterdam, 1842), G.-F. Waagen (Paris, 1863), A. Michiels (Paris, 1864), H. Taine (Paris, 1865), A. Siret (Brussels, 1872), E. Fromentin (Paris, 1876). A true critical revaluation of the master began with the works of W. Burger-Thoré, J. Rousseau and, above all, H. Hymans, all published in Brussels in the years 1862, 1882 and 1890 respectively. From the beginning of our century numerous articles and books aimed at spreading a deeper understanding and shedding light on every aspect of Bruegel's art have been and are being published. The following are some of the more important:

R. VAN BASTELAER and G. HULIN DE LOO. *Peter Bruegel l'Ancien, son oeuvre et son temps*, Brussels, 1905.

G. GLÜCK. *Peter Bruegels des Aelteren Gemälde im Kunsthistorischen Hofmuseum zu Wien*, Brussels, 1910.

M. J. FRIEDLÄNDER. *Pieter Bruegel*, Berlin, 1921.

M. DVORÀK. "Pieter Bruegel", in *Kunstgeschichte als Geistesgeschichte*, Munich, 1924.

E. MICHEL. *Bruegel*, Paris, 1931.

G. GLÜCK. *Bruegels Gemälde*, Vienna, 1934.

C. DE TOLNAY. *Pierre Bruegel l'Ancien*, Brussels, 1935.

M. J. FRIEDLÄNDER. *Die altniederländische Malerei*, XIV, Leyden, 1937.

G. JEDLICKA. *Pieter Breughel. Der Maler in seiner Zeit*, Zurich, 1938.

C. TERLINDEN. "Pierre Bruegel le Vieux et l'histoire", in *Revue belge d'archéologie et d'histoire de l'art*, XII, 1942, pp. 229–57.

J. MULS. *Bruegel*, Antwerp, 1945.

A. STUBBE. *Bruegel en de Renaissance. Het probleem van het manierisme*, Antwerp, 1947.

R. GENAILLE. *Bruegel l'Ancien*, Paris–Brussels, 1953.

R. L. DELEVOY. *Bruegel*, Paris, 1953; Geneva, 1959.

F. GROSSMANN. "The Drawings of Pieter Bruegel the Elder", in *Bulletin of the Museum Boymans*, V, July 2, 1954, pp. 41–63.

F. GROSSMANN. *Bruegel. The Paintings*, London, 1955.

J. BIALOSTOCKI. *Bruegel pejzażysta*, Poznan, 1956.

C. G. STRIDBECK. *Bruegelstudien . . .*, Stockholm, 1956.

F. WÜRTENBERGER. *Pieter Bruegel der Ältere und die deutsche Kunst*, Wiesbaden, 1957.

REPRODUCTIONS

ACKNOWLEDGEMENT FOR
REPRODUCTIONS

Plates 1–7, 9, 10, 31–9, 44–6, 60, 88–9, 90–7, 114–21, 126–31, 144–8, 158–60: *Archives Centrales Iconographiques d'Art National, Brussels*. Plates 8, 40–1, 42, 43, 138, 143: *Anderson, Rome*. Plates 11, 19–23, 24–5, 26–30, 48–56, 66–70, 72–3, 74–7, 84–7, 122–5, 132–5, 150–7: *Kunsthistorisches Museum, Vienna*. Plates 12–18, 47: *State Museums, Berlin*. Plates 57–9, *Lichtbeelden Instituut, Amsterdam*. Plates 61–5, 71: *National Gallery, London*. Plates 78–83: *Metropolitan Museum of Art, New York*. Plates 98–101, 102 and 103, 104–5: *the owners*. Plates 106–9: *Institute of Arts, Detroit*. Plates 110–13: *Museum, Budapest*. Plates 136 and 137: *H. Linck, Winterthur*. Plates 139 and 142 and choice of color plates: *Claudio Emmer Milan*. Plate 149: *Bulloz, Paris*.

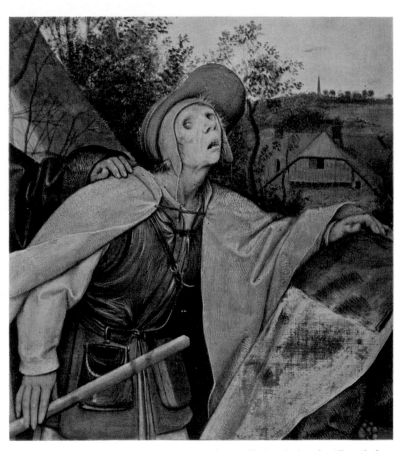

THE PARABLE OF THE BLIND, Naples, Gallerie Nazionale. (*Detail of plate 138*)

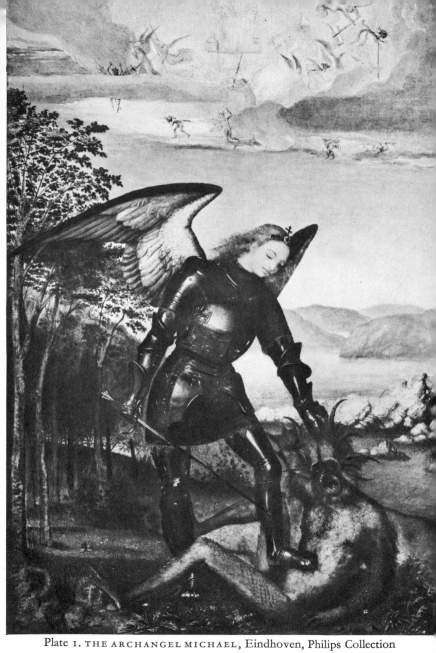

Plate I. THE ARCHANGEL MICHAEL, Eindhoven, Philips Collection

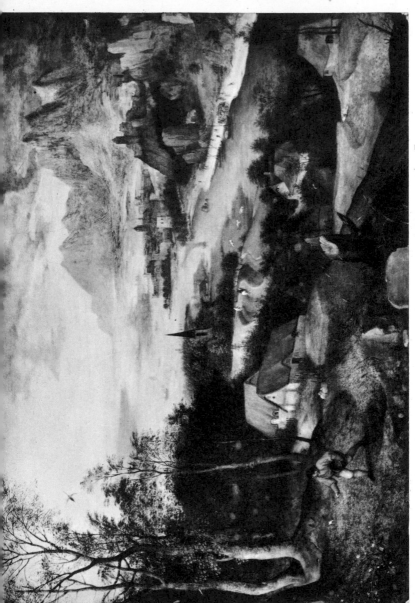

Plate 2. RIVER LANDSCAPE WITH PEASANT SOWING, Antwerp, Museum voor Schone Kunsten

Plate 3. THE ADORATION OF THE MAGI, Brussels, Musées Royaux des Beaux-Arts

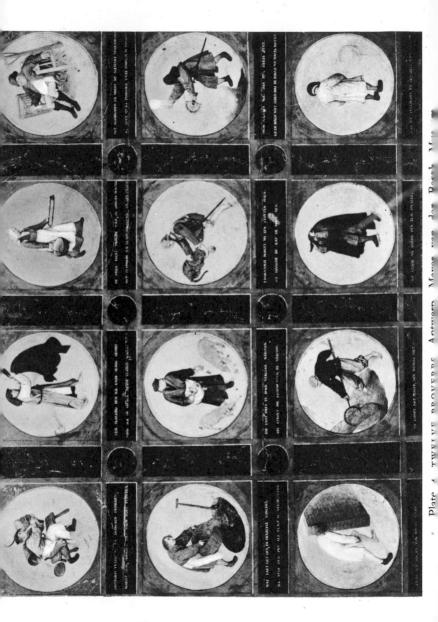

Plate 4 TWELVE PROVERBS Antwerp, Museum van den Bergh

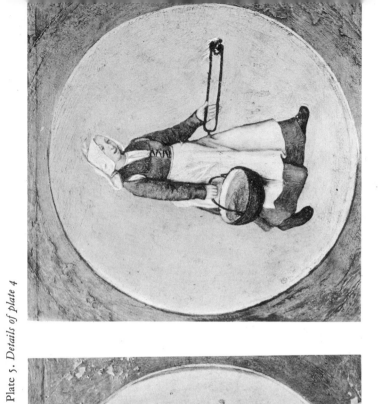

Plate 5. *Details of plate 4*

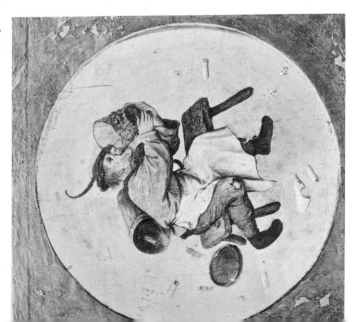

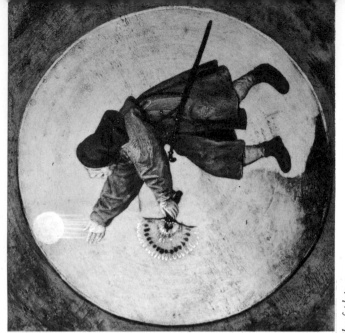

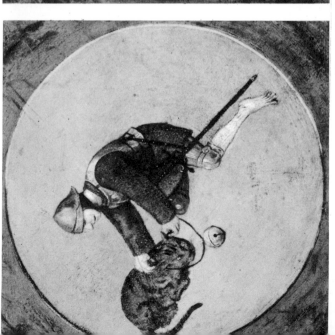

Plate 6. *Details of plate 4*

Plate 7. Details of plate 4

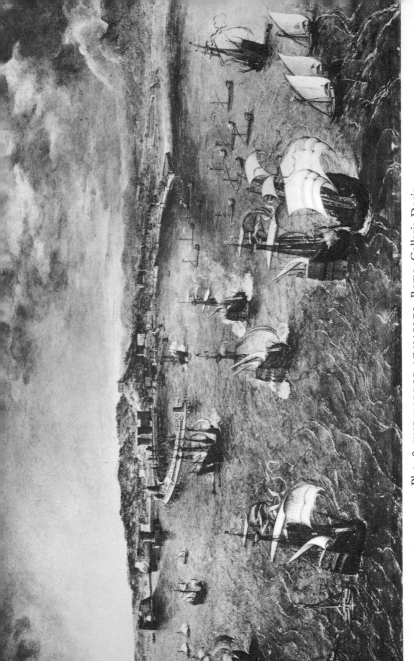

Plate 8. THE HARBOR AT NAPLES, Rome, Galleria Doria

Plate 9. FALL OF ICARUS, Brussels, Musées Royaux des Beaux-Arts

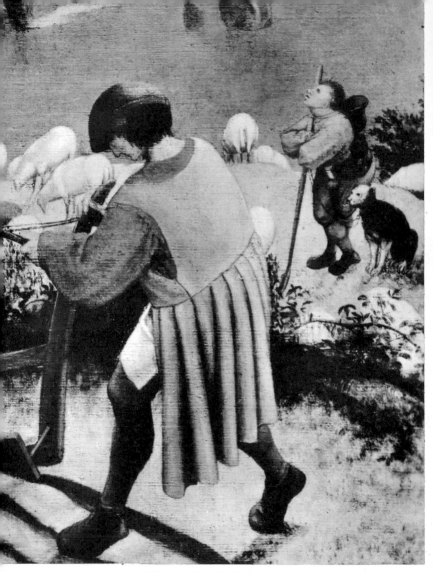

Plate 10. *Detail of plate 9*

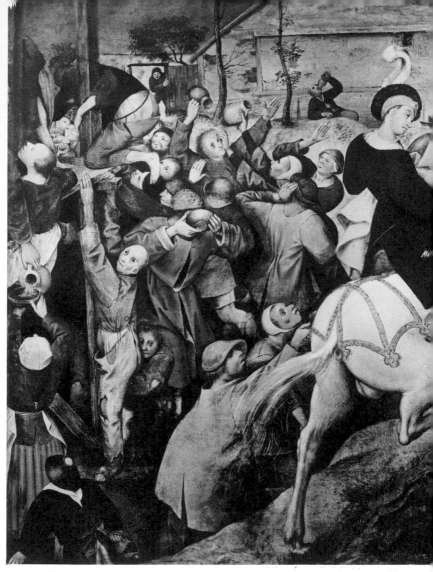

Plate 11. THE WINE OF ST MARTIN, Vienna, Kunsthistorisches Museum

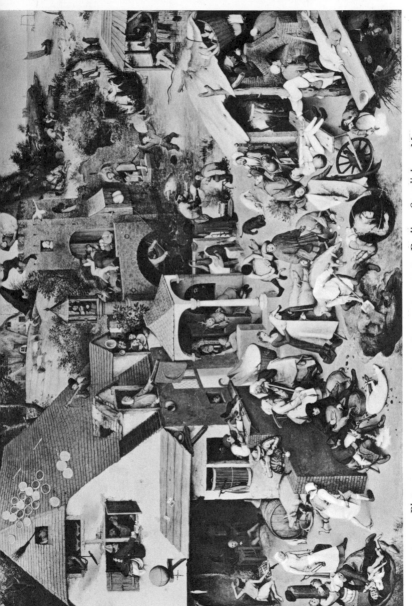

Plate 12. THE NETHERLANDISH PROVERBS, Berlin, Staatliche Museum

Plate 13. *Detail of plate 12*

Plate 14. *Detail of plate 12*

Plate 15. *Detail of plate 12*

Plate 16. *Detail of plate 12*

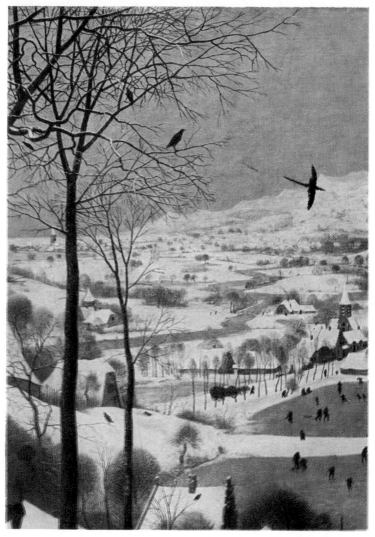

THE HUNTERS IN THE SNOW, Vienna, Kunsthistorisches Museum.
(*Detail of plates 88–89*)

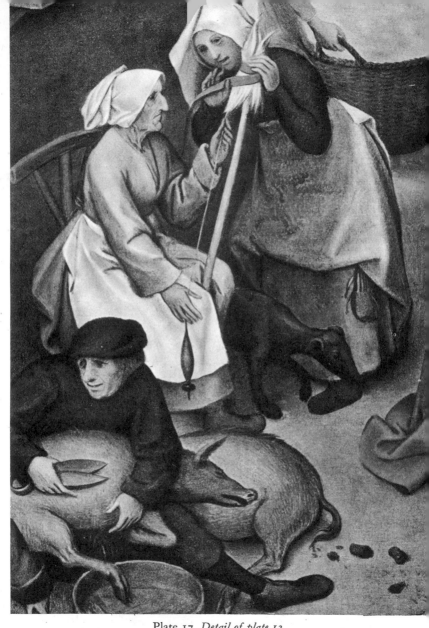

Plate 17. *Detail of plate 12*

Plate 18. *Detail of plate 12*

Plate 19. THE BATTLE BETWEEN CARNIVAL AND LENT, Vienna:
Kunsthistorisches Museum

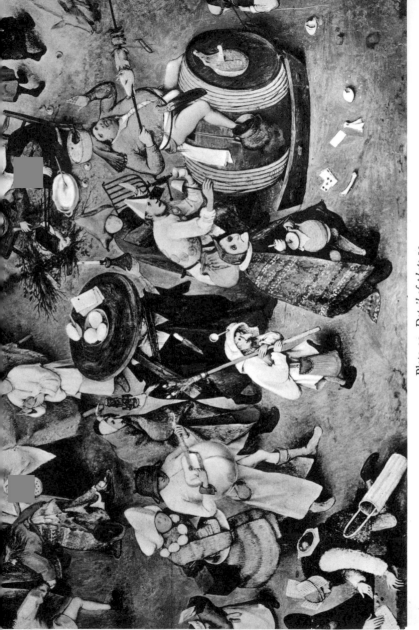

Plate 20. *Detail of plate 19*

Plate 21. *Detail of plate 19*

Plate 22. *Detail of plate 19*

Plate 23. *Detail of plate 19*

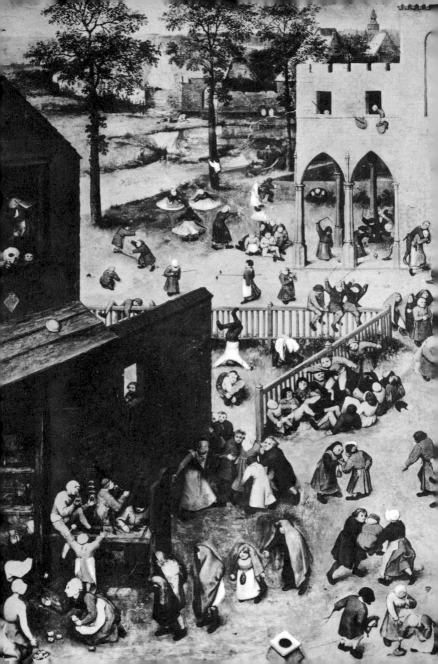

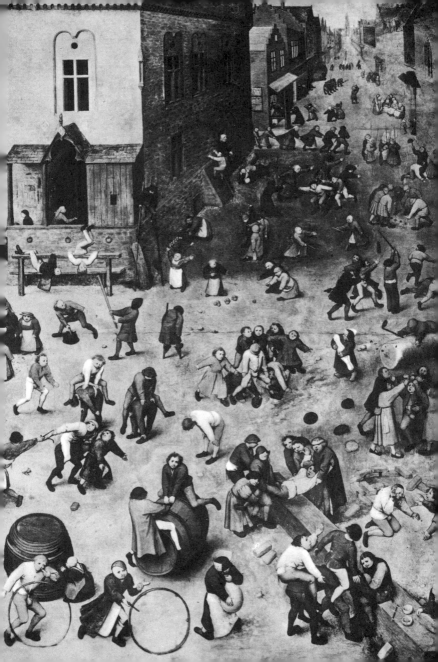

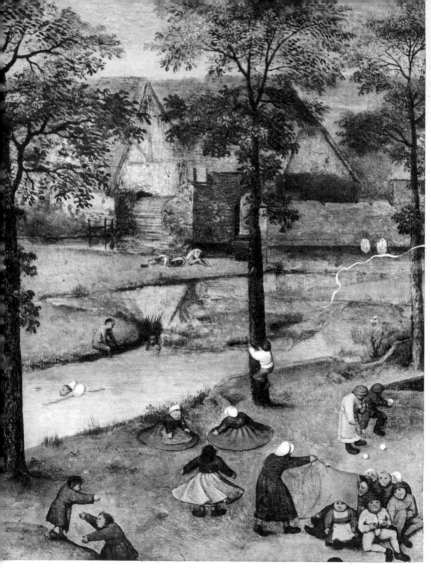

Plate 26. *Detail of plates 24–25*

Previous page: Plates 24–25. CHILDREN'S GAMES, Vienna, Kunsthistorisches Museum

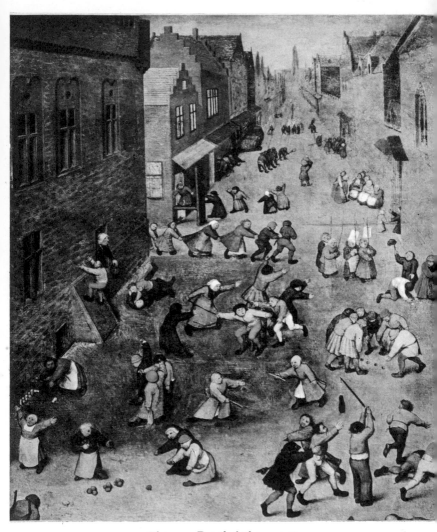

Plate 27. *Detail of plates 24–25*

Plate 28. *Detail of plates 24-25*

Plate 29. *Detail of plates 24–25*

Plate 30. *Detail of plates 24–25*

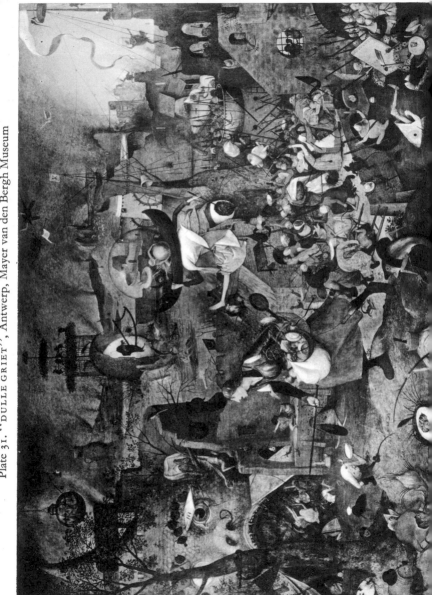

Plate 31. "DULLE GRIET", Antwerp, Mayer van den Bergh Museum

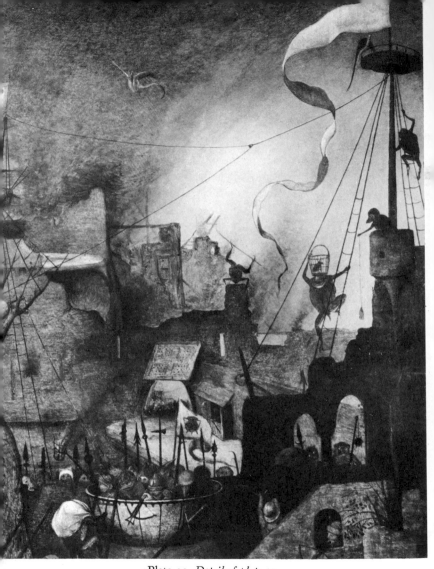

Plate 32. *Detail of plate 31*

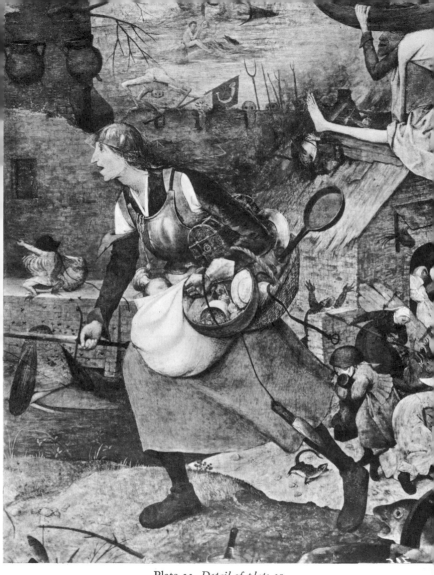

Plate 33. *Detail of plate 31*

Plate 34. *Detail of plate 31*

Plate 35. *Detail of plate 31*

Plate 36. *Detail of plate 31*

Plate 37. *Detail of plate 31*

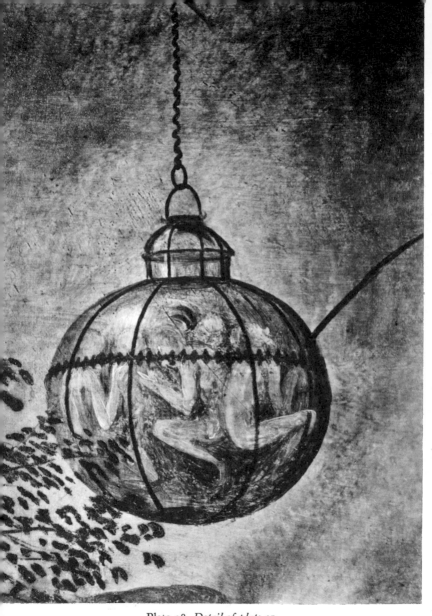

Plate 38. *Detail of plate 31*

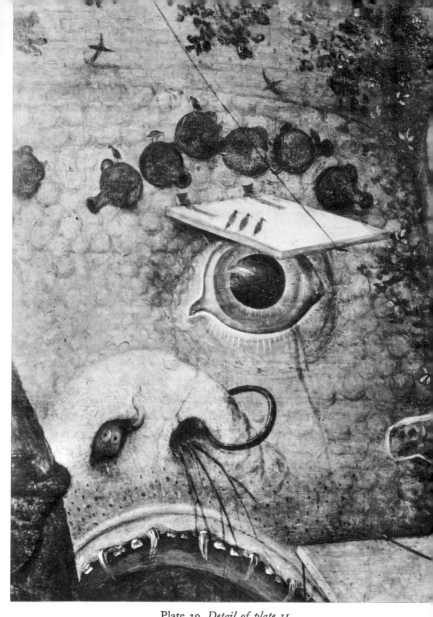

Plate 39. *Detail of plate 31*

Overleaf: Plates 40–41. THE TRIUMPH OF DEATH, Madrid, Prado

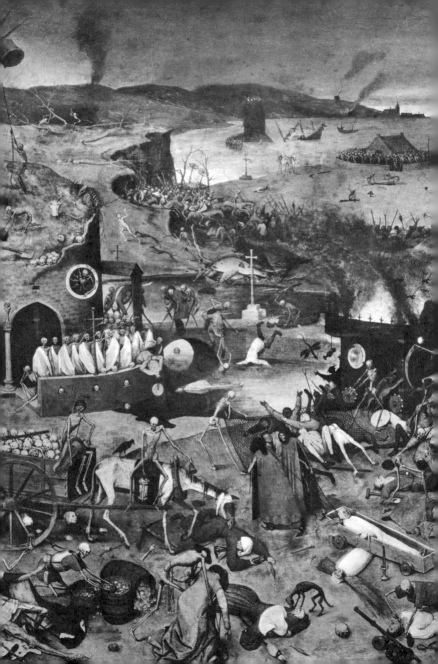

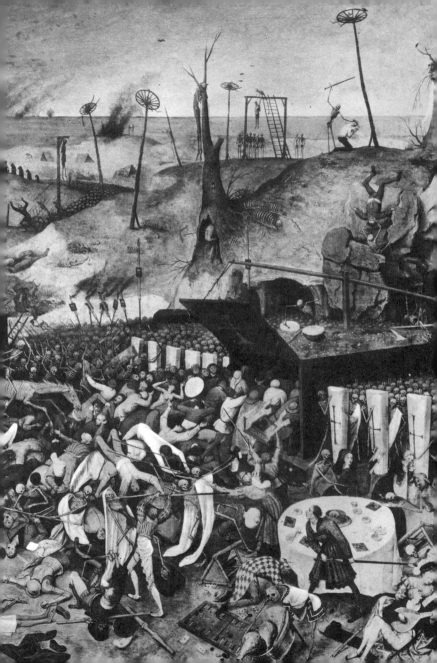

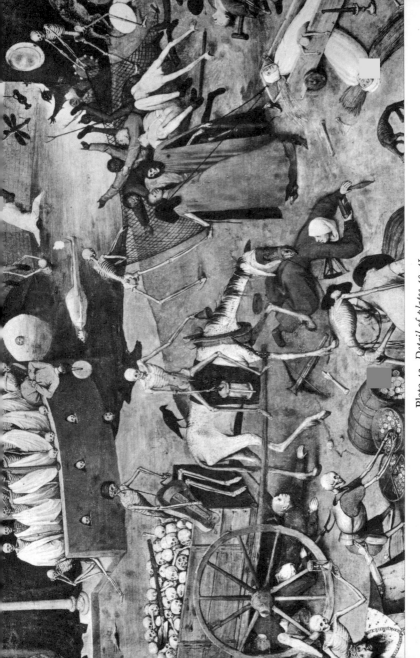

Plate 42. *Detail of plates 40–41*

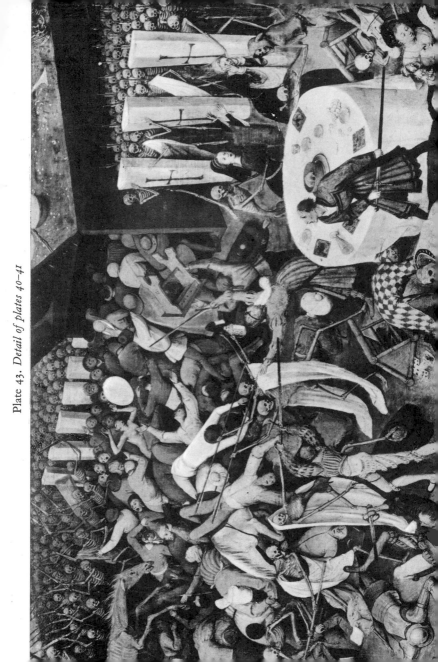

Plate 43. Detail of plates 40–41

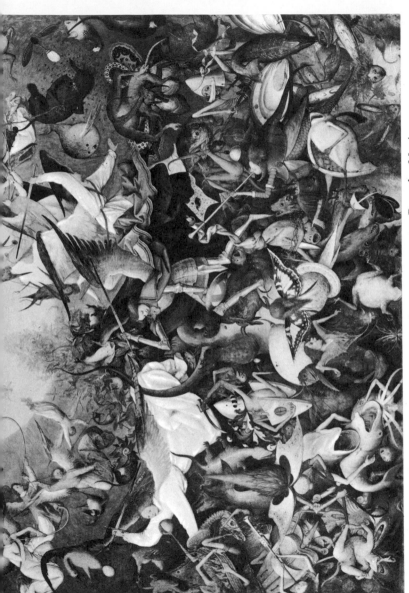

Plate 44. THE FALL OF THE REBEL ANGELS, Brussels, Musées Royaux des Beaux-Arts

Plate 45. *Detail of plate 44*

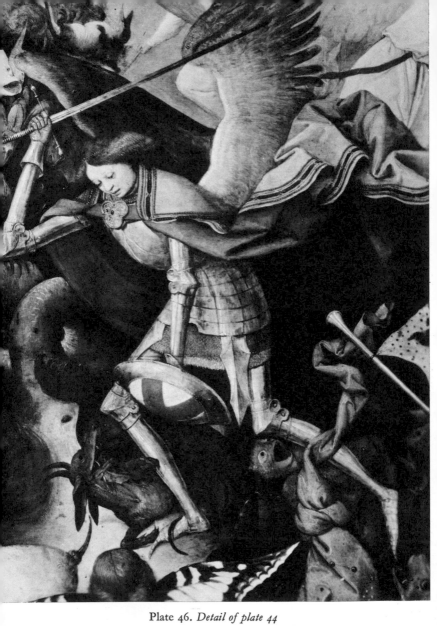

Plate 46. *Detail of plate 44*

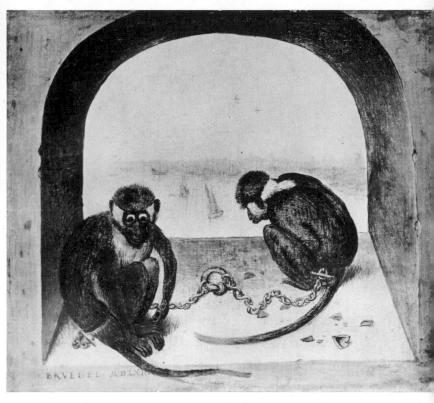

Plate 47. TWO MONKEYS, Berlin, Staatliche Museen

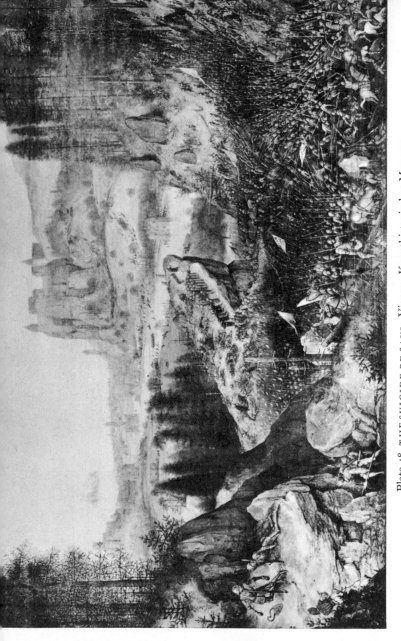

Plate 48. THE SUICIDE OF SAUL, Vienna, Kunsthistorisches Museum

Plate 49. *Detail of plate 48*

Plate 50. *Detail of plate 48*

Plate 51. THE TOWER OF BABEL, Vienna, Kunsthistorisches Museum

Plate 52. *Detail of plate 51*

Plate 53. *Detail of plate 51*

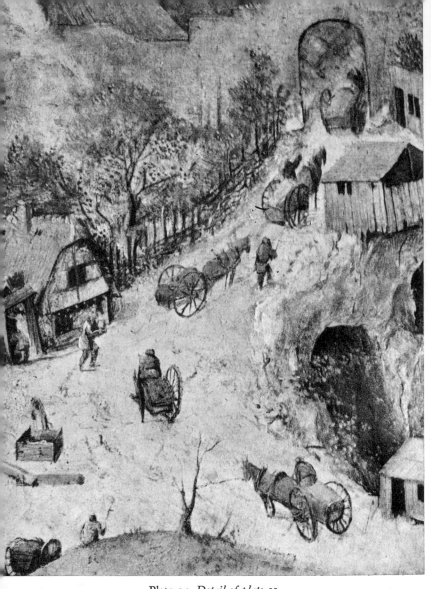

Plate 54. *Detail of plate 51*

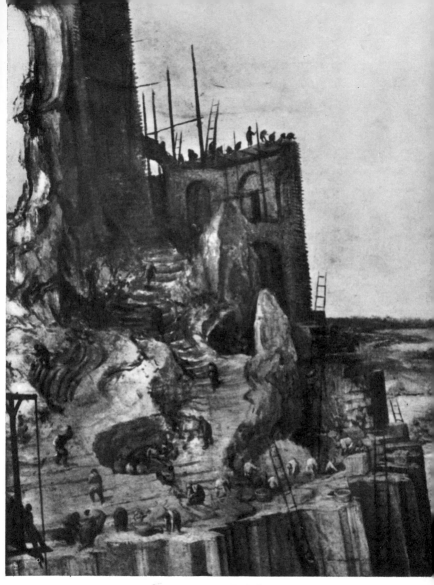

Plate 55. *Detail of plate 51*

Plate 56. *Detail of plate 51*

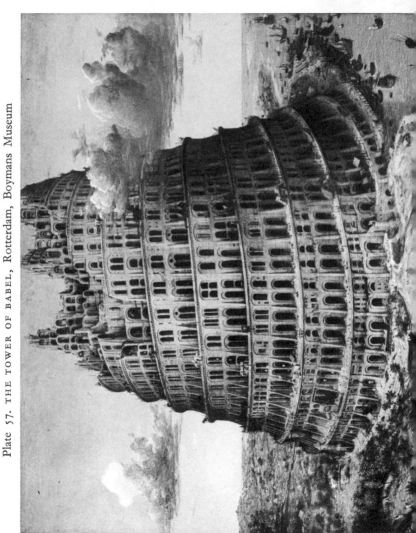

Plate 57. THE TOWER OF BABEL, Rotterdam, Boymans Museum

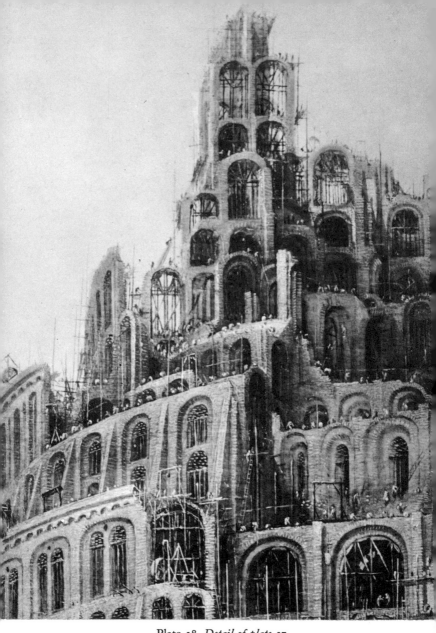

Plate 58. *Detail of plate 57*

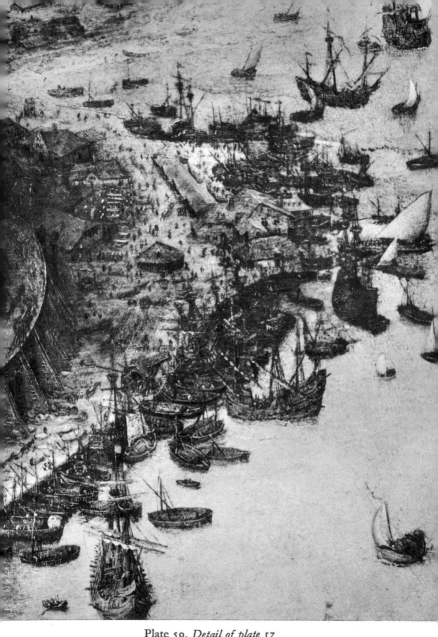

Plate 59. *Detail of plate 57*

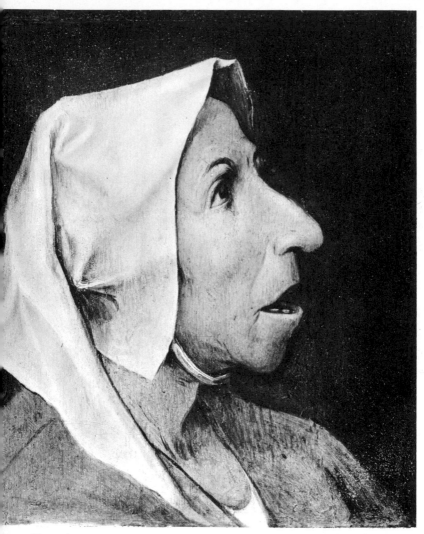

Plate 60. HEAD OF AN OLD PEASANT WOMAN, Munich, Alte
Pinakothek

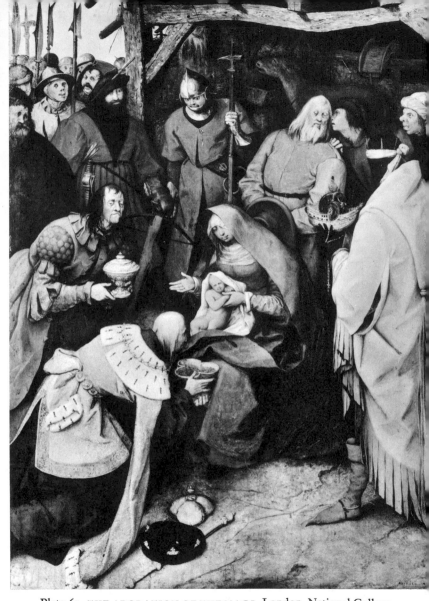

Plate 61. THE ADORATION OF THE MAGI, London, National Gallery

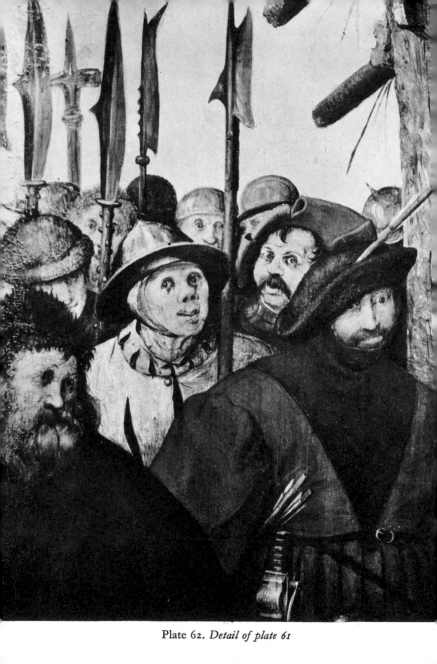

Plate 62. *Detail of plate 61*

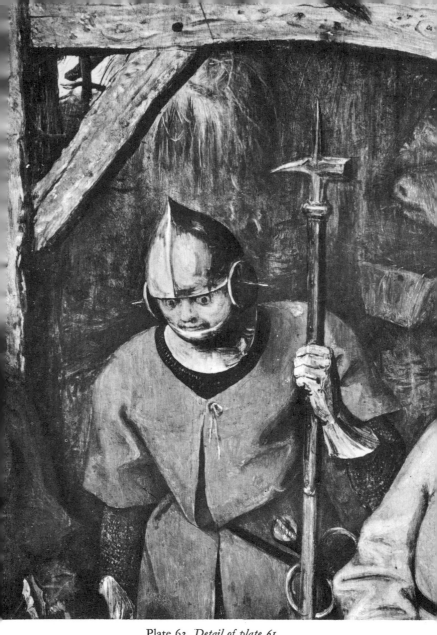

Plate 63. *Detail of plate 61*

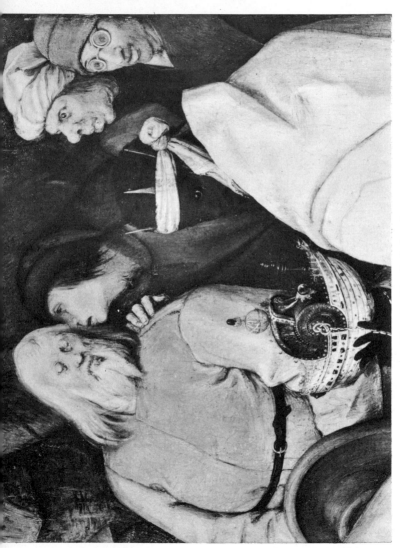

Plate 64. *Detail of plate 61*

Plate 64. *Detail of plate 61*

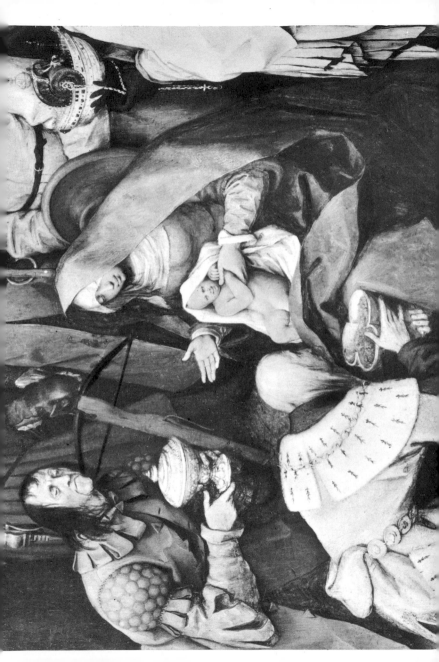

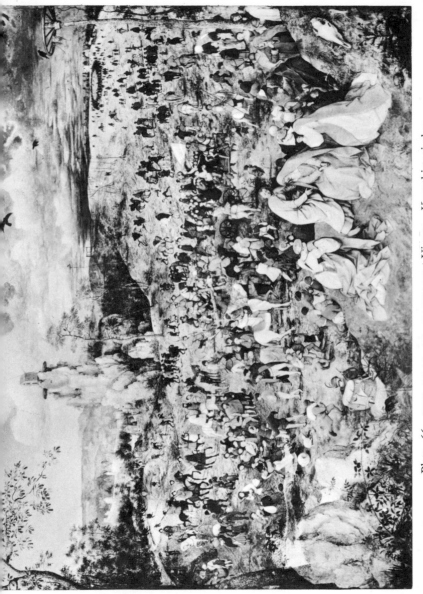

Plate 66. THE ROAD TO CALVARY, Vienna, Kunsthistorisches

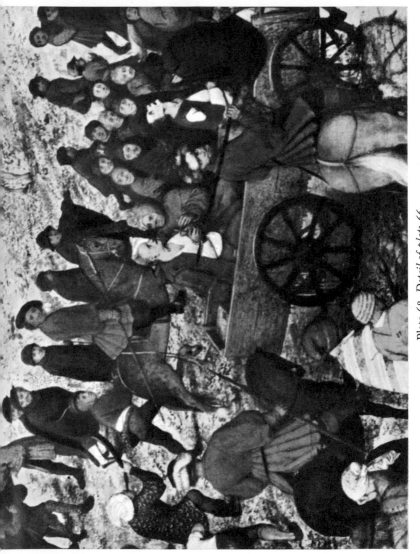

Plate 68. *Detail of plate 66*

Plate 69. *Detail of plate 66*

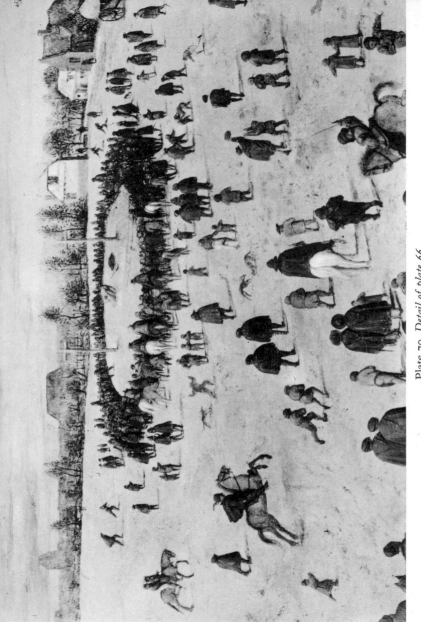

Plate 70. Detail of plate 66

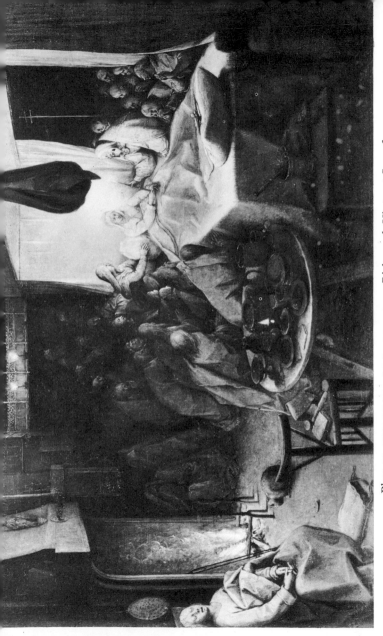

Plate 71. THE DEATH OF THE VIRGIN, Richmond, Viscount Lee of
Fareham Collection

Overleaf: Plates 72–73. THE STORMY DAY (MARCH), Vienna,
Kunsthistorisches Museum

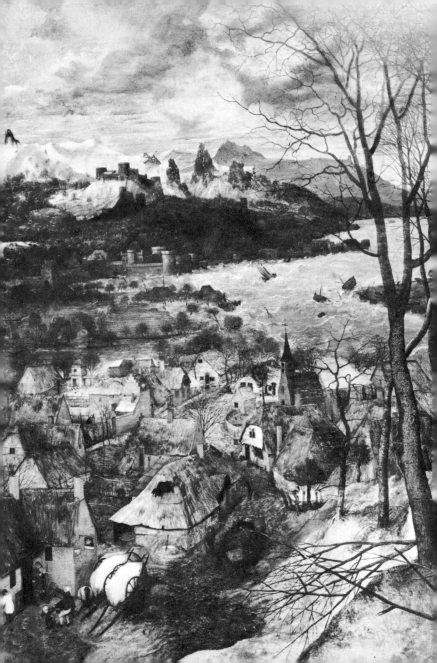

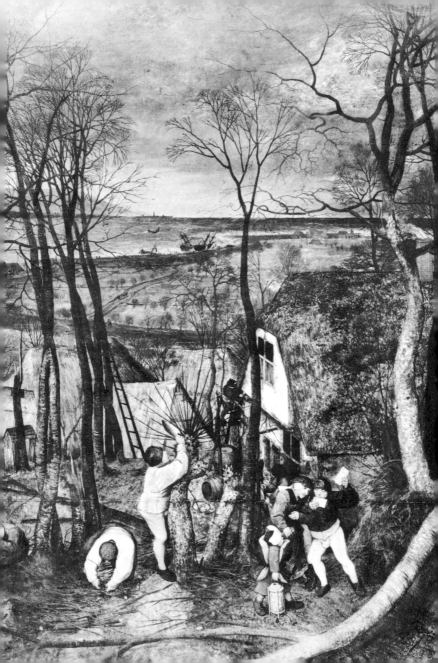

Plate 74. *Detail of plates 72–73*

Plate 75. *Detail of plates 72–73*

Plate 76. *Detail of plates 72–73*

Plate 77. *Detail of plates 72–73*

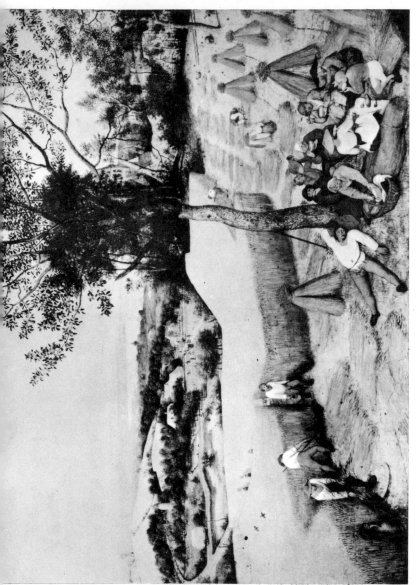

Plate 78. THE CORN HARVEST, New York, Metropolitan Museum

Plate 79. *Detail of plate 78*

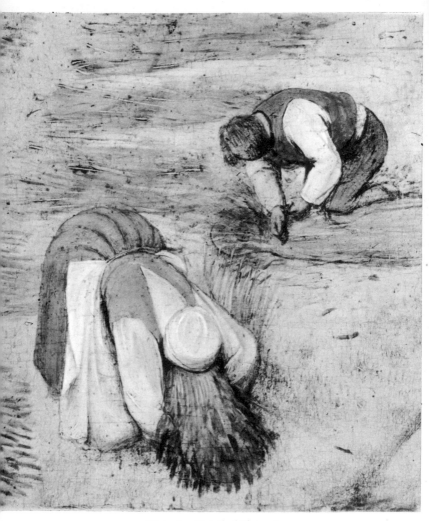

Plate 80. *Detail of plate 78*

Plate 81. *Detail of plate 78*

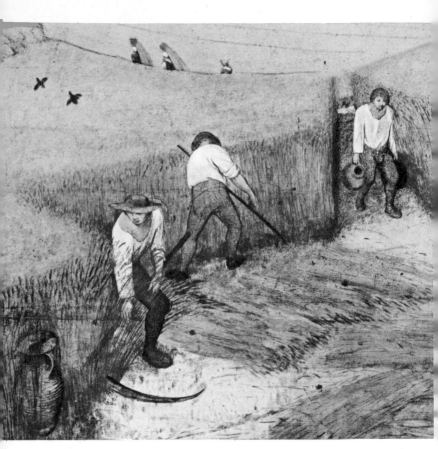

Plate 82. *Detail of plate 78*

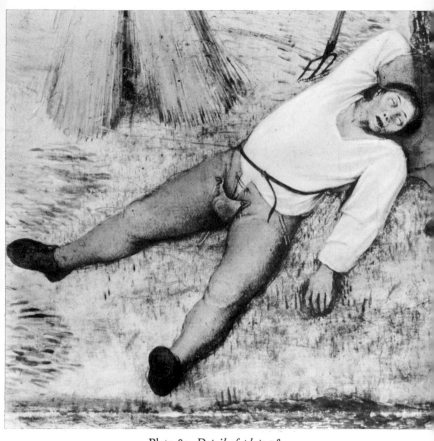

Plate 83. *Detail of plate 78*

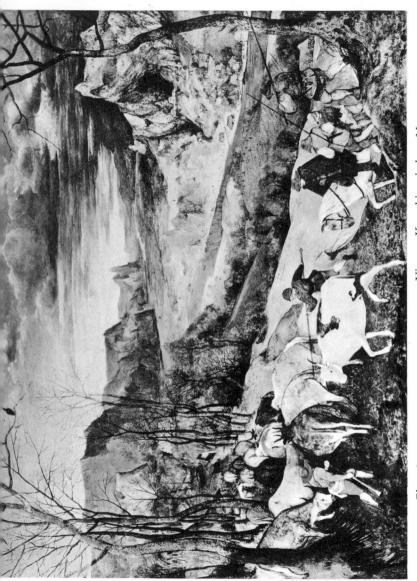

Plate 84. THE RETURN OF THE HERD, Vienna, Kunsthistorisches Museum

Plate 85. *Detail of plate 84*

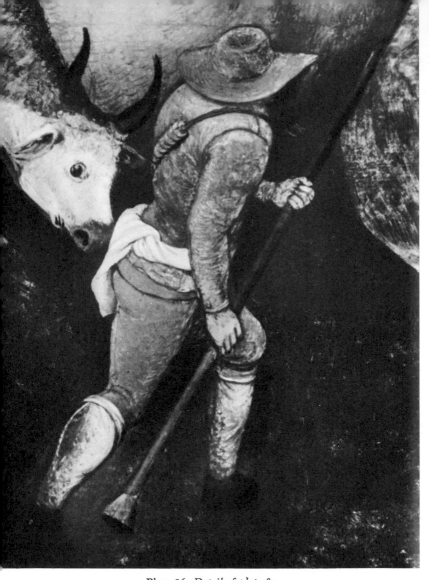

Plate 86. *Detail of plate 84*

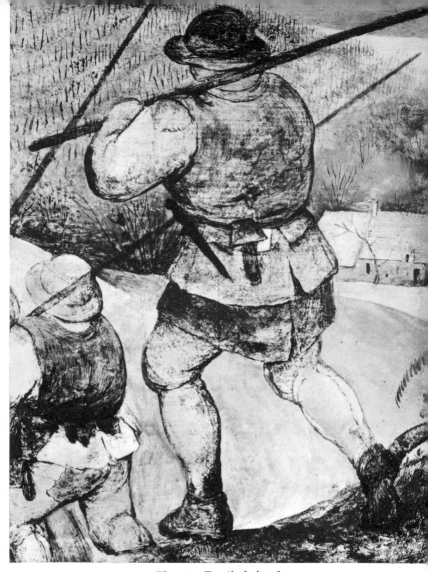

Plate 87. *Detail of plate 84*

Overleaf: Plates 88–89. THE HUNTERS IN THE SNOW, Vienna,
Kunsthistorisches Museum

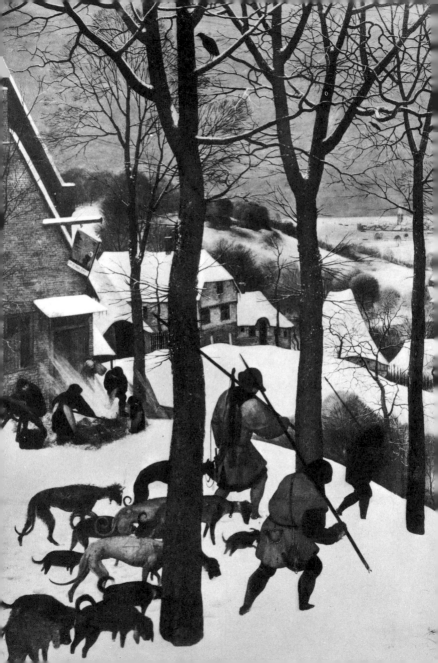

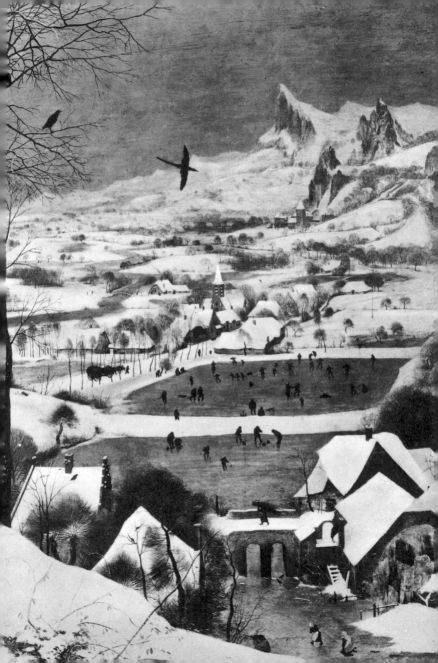

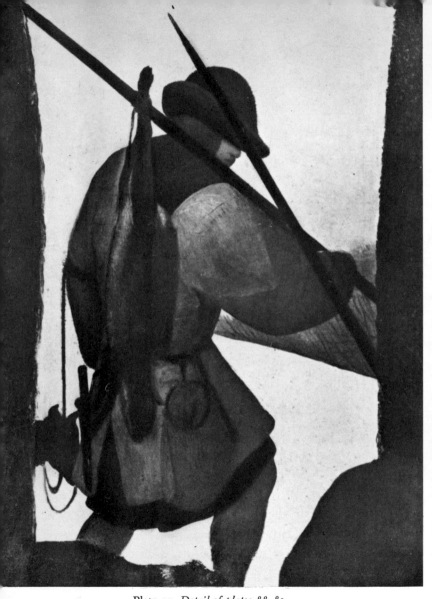

Plate 90. *Detail of plates 88–89*

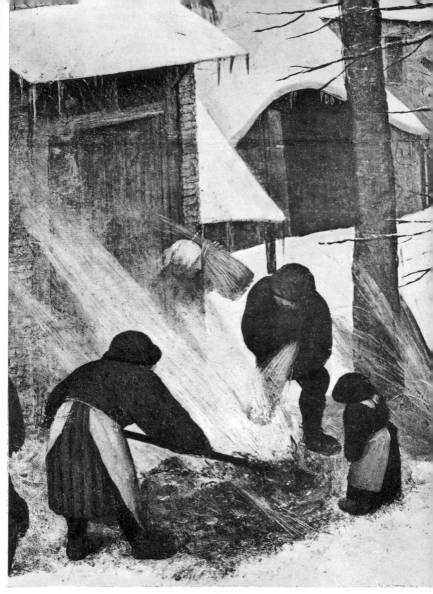

Plate 91. *Detail of plates 88–89*

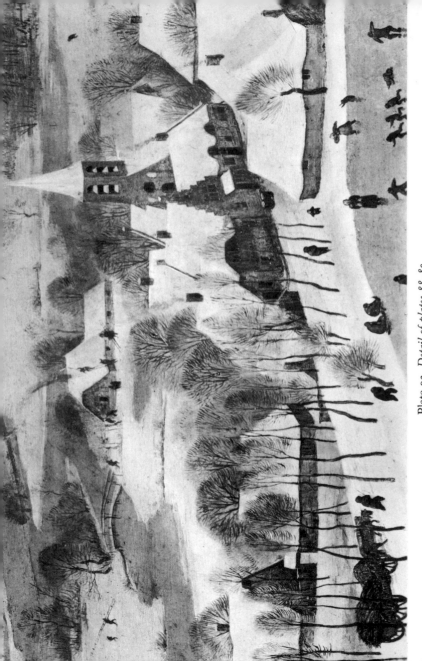

Plate 92. *Detail of plates 88–89*

Plate 93. Detail of plates 88–89

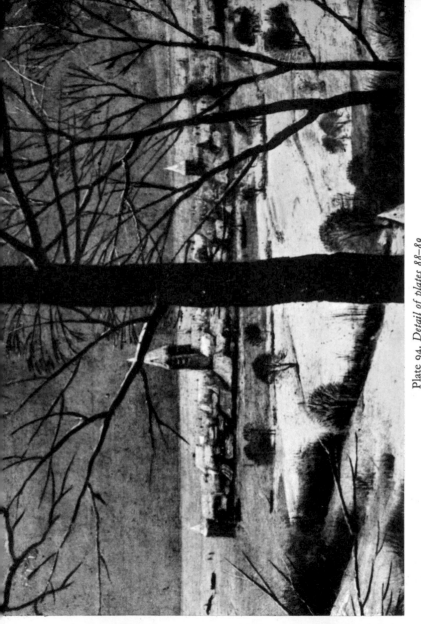

Plate 94. *Detail of plates 88–89*

Plate 95 · WINTER LANDSCAPE, Brussels, Delporte Collection

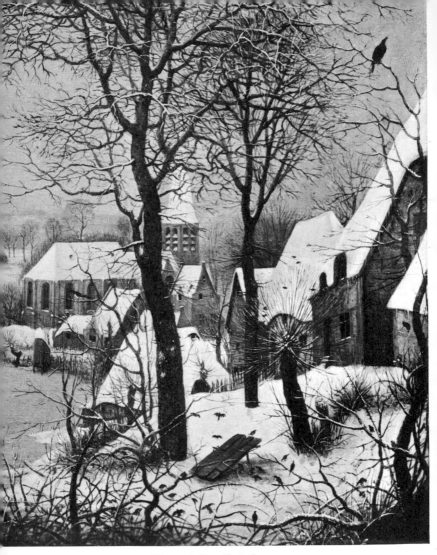

Plate 96. *Detail of plate 95*

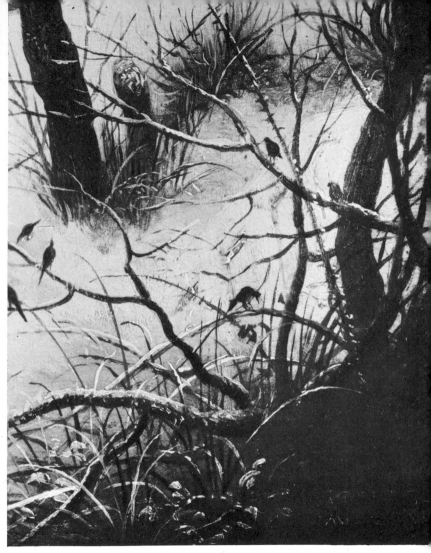

Plate 97. *Detail of plate 95*

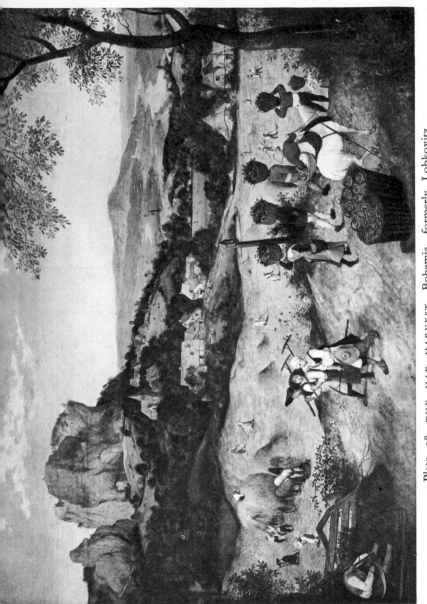

Plate 98. THE HAY HARVEST, Bohemia, formerly Lobkovitz

Plate 99. *Detail of plate 98*

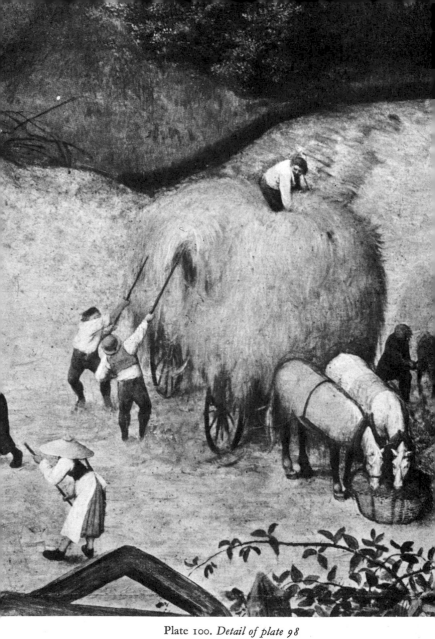

Plate 100. *Detail of plate 98*

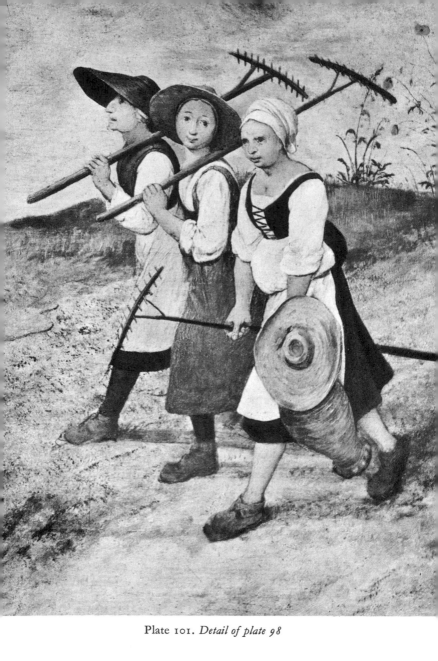

Plate 101. *Detail of plate 98*

Plate 102. PEASANTS DANCING BEFORE THE INN, Lugano, Schloss
Rohoncz Collection

Plate 103. *Detail of plate 102*

Plates 104–105. WEDDING PROCESSION, Northwick Park, Churchill
Collection

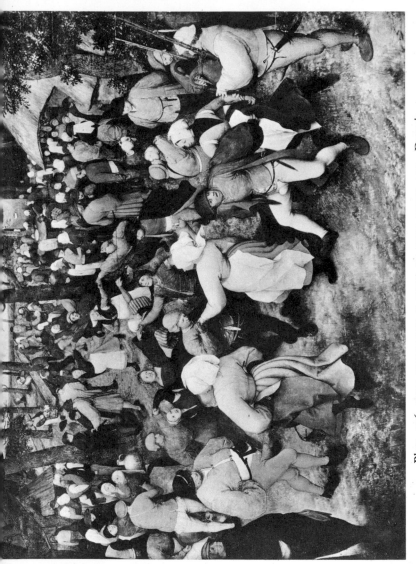

Plate 106. THE WEDDING DANCE IN THE OPEN AIR, Detroit,
Institute of Arts

Plate 107. *Detail of plate 106*

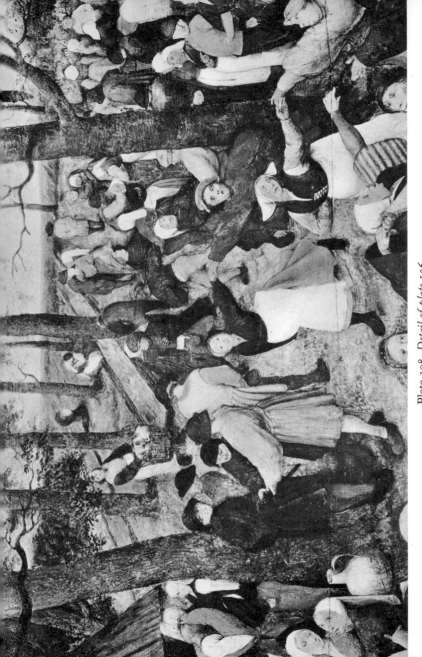

Plate 108. *Detail of plate 106*

Plate 109. *Detail of plate 106*

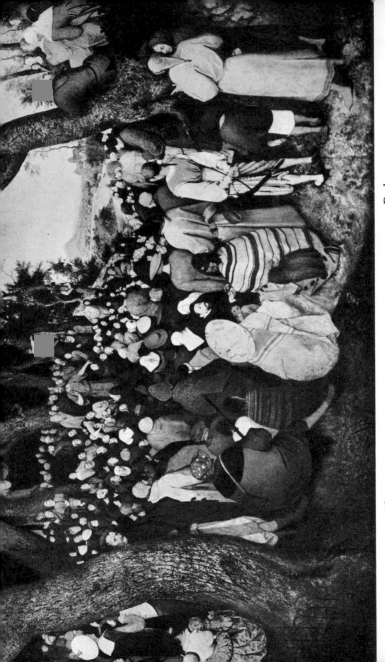

Plate 110. ST JOHN PREACHING IN THE WILDERNESS, Budapest

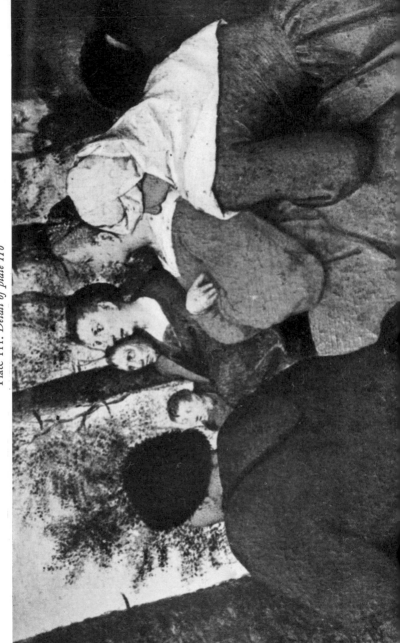

Plate 111. *Detail of plate 110*

Plate 112. *Detail of plate 110*

Plate 113. *Detail of plate 110*

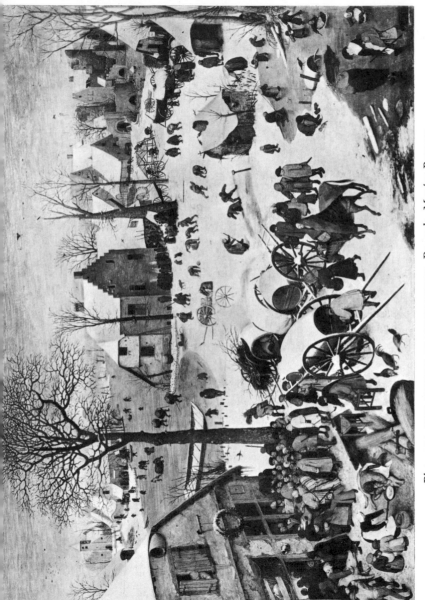

Plate 114. THE CENSUS AT BETHLEHEM, Brussels, Musées Royaux

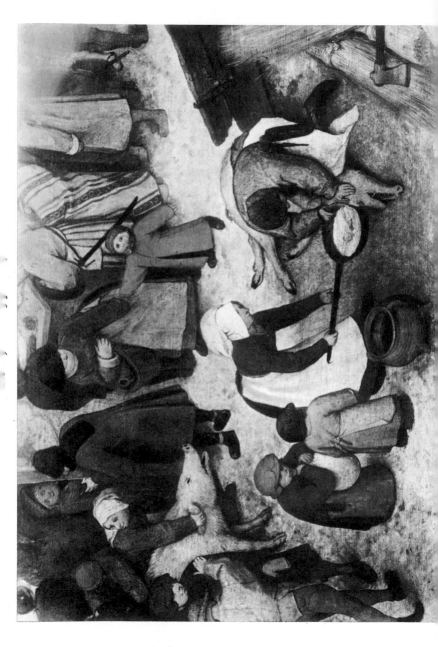

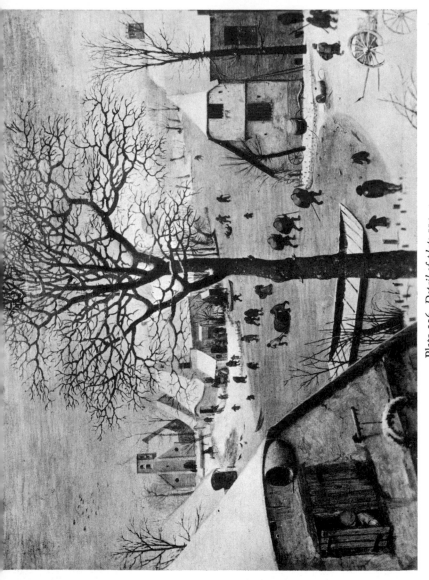

Plate 116. *Detail of plate 114*

Plate 117. *Detail of plate 114*

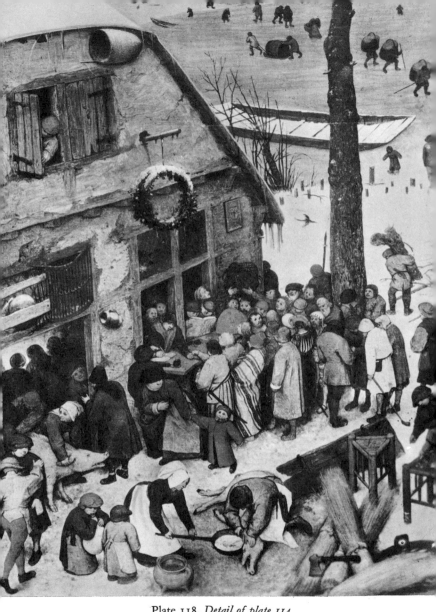

Plate 118. *Detail of plate 114*

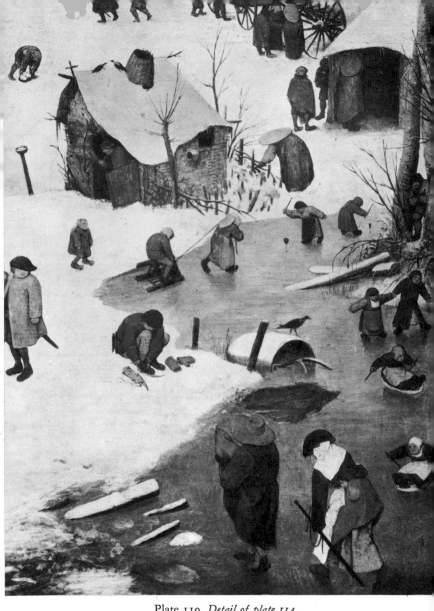

Plate 119. *Detail of plate 114*

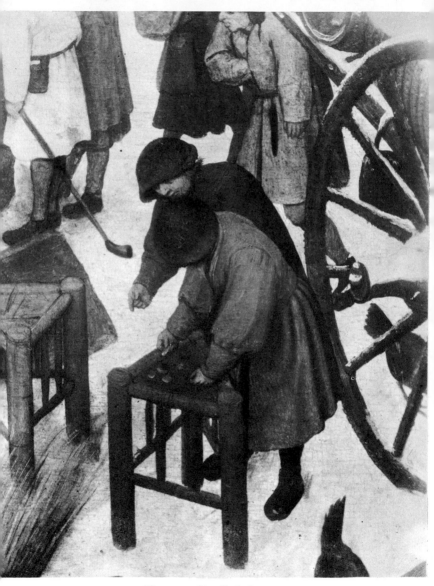

Plate 120. *Detail of plate 114*

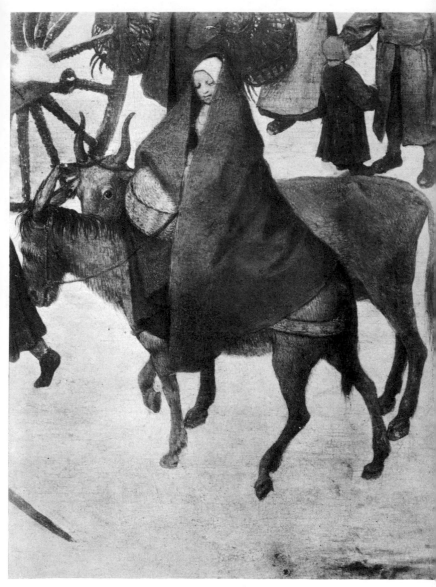

Plate 121. *Detail of plate 114*

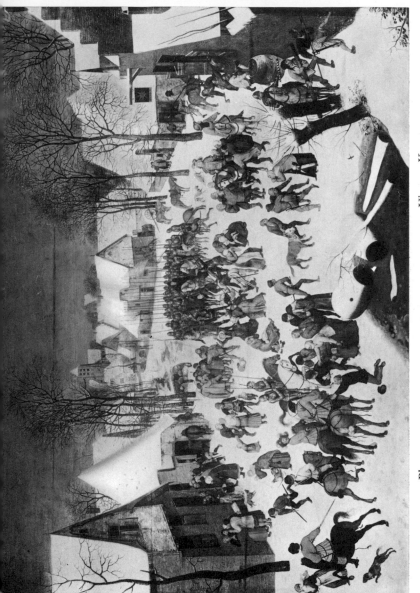

Plate 122. THE MASSACRE OF THE INNOCENTS, Vienna, Kunst-historisches Museum

Plate 123. *Detail of plate 122*

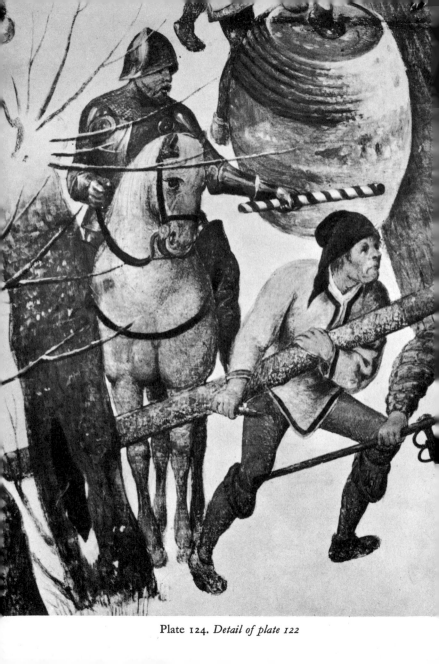

Plate 124. *Detail of plate 122*

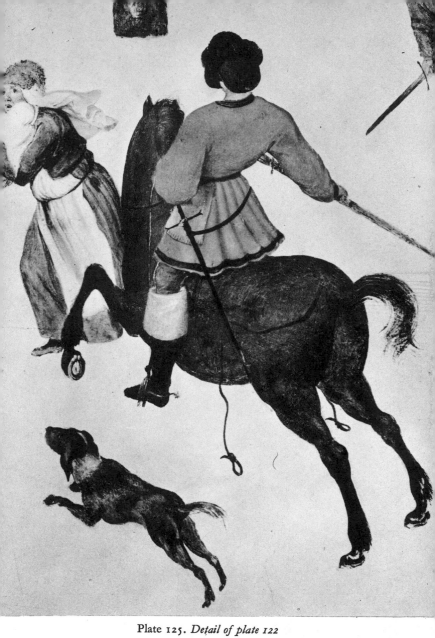

Plate 125. *Detail of plate 122*

Plate 126. THE LAND OF COCKAYNE, Munich, Alte Pinakothek

Plate 127. *Detail of plate 126*

Plate 128. *Detail of plate 126*

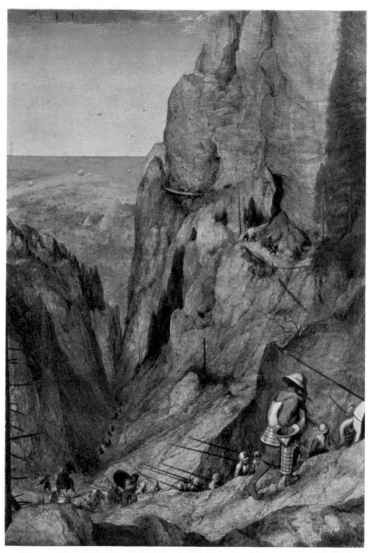

THE CONVERSION OF ST PAUL, Vienna, Kunsthistorisches Museum.
(*Detail of plate 132*)

Plate 129. *Detail of plate 126*

Plate 130. *Detail of plate 126*

Plate 131. *Detail of plate 126*

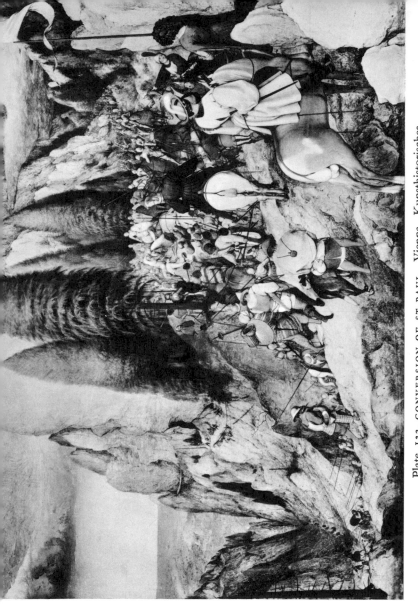

Plate 132. CONVERSION OF ST PAUL, Vienna, Kunsthistorisches
Museum

Plate 133. Detail of plate 132

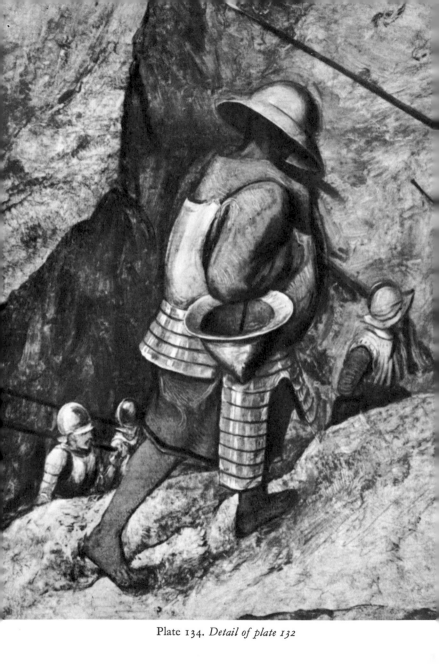

Plate 134. *Detail of plate 132*

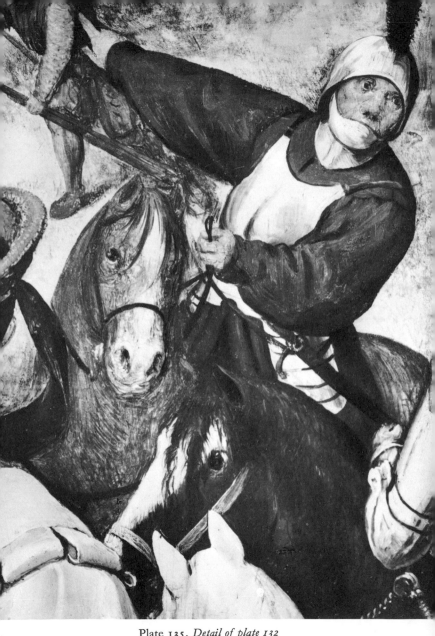

Plate 135. *Detail of plate 132*

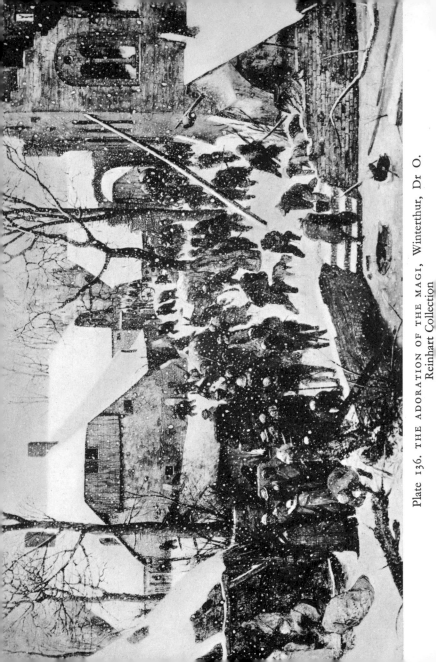

Plate 136. THE ADORATION OF THE MAGI, Winterthur, Dr O.
Reinhart Collection

Plate 137. *Detail of plate 136*

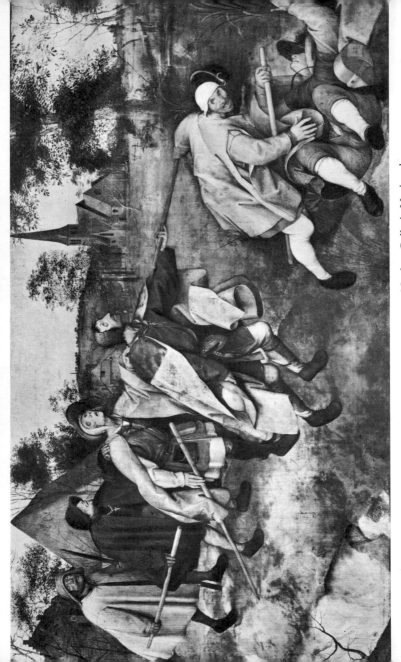

Plate 138. THE PARABLE OF THE BLIND, Naples, Gallerie Nazionale

Plate 139. *Detail of plate 138*

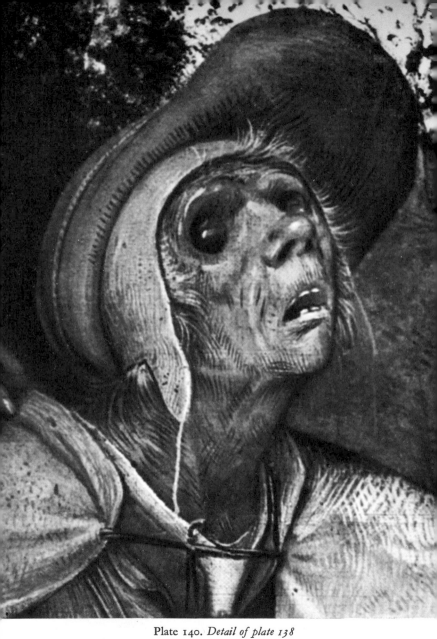

Plate 140. *Detail of plate 138*

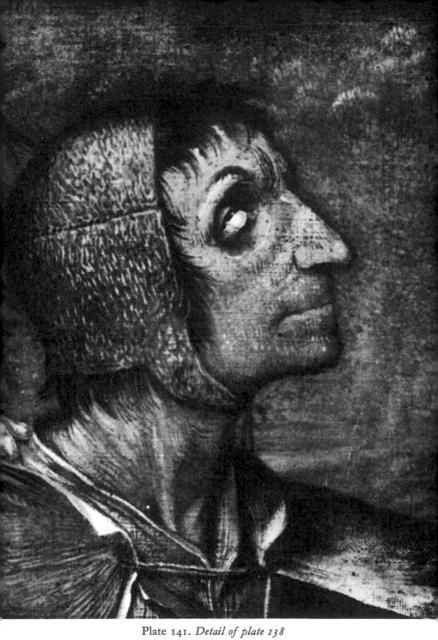

Plate 141. *Detail of plate 138*

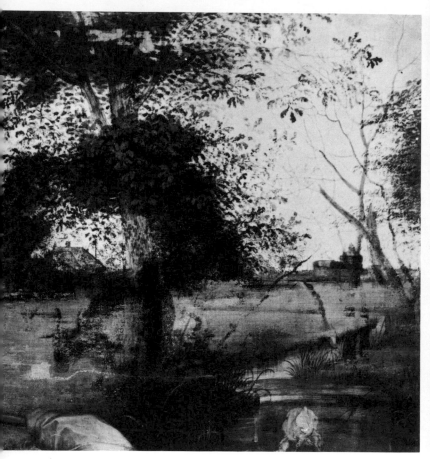

Plate 142. *Detail of plate 138*

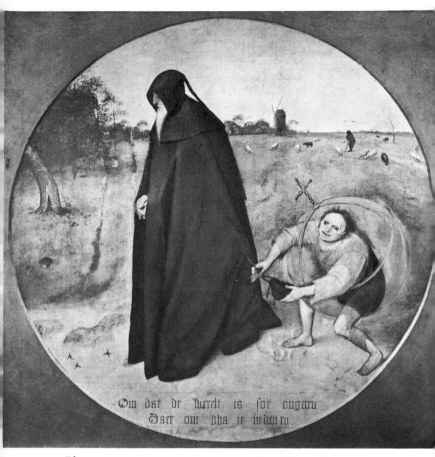

Om dat de werelt is soe ongetru
Daer om gha ic in den ru

Plate 143. THE MISANTHROPE, Naples, Gallerie Nazionale

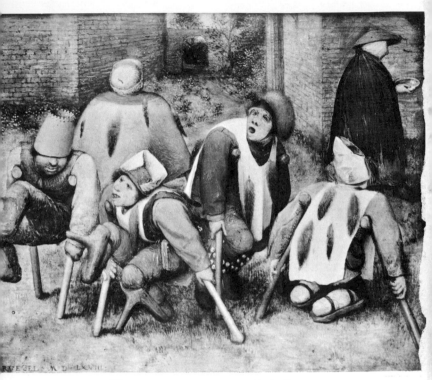

Plate 144. THE CRIPPLES, Paris, Louvre

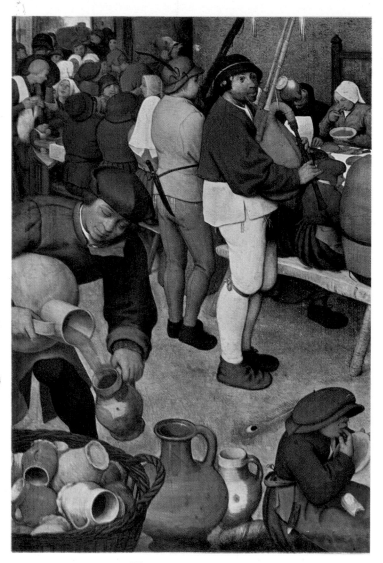

PEASANT WEDDING, Vienna, Kunsthistorisches Museum. (*Detail of plate 150*)

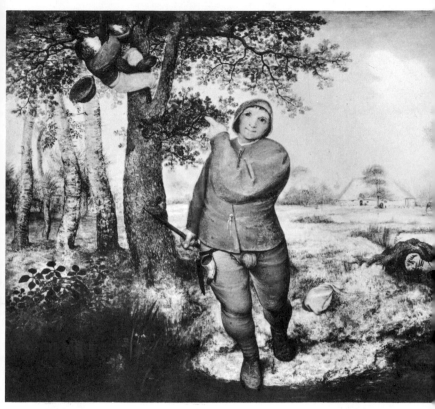

Plate 145. THE NEST ROBBER, Vienna, Kunsthistorisches Museum

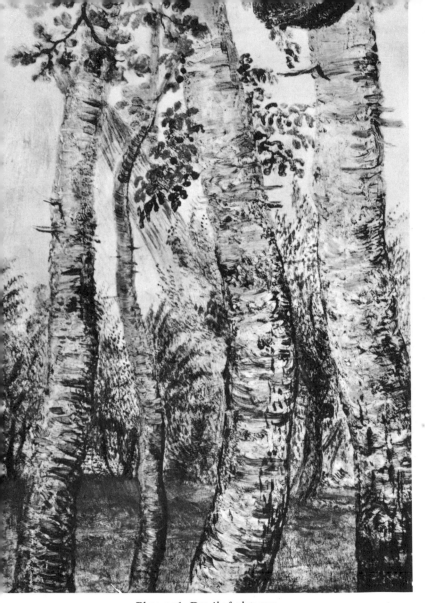

Plate 146. *Detail of plate 145*

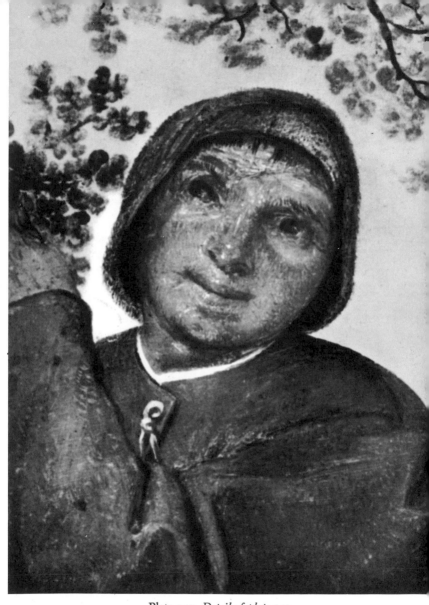

Plate 147. *Detail of plate 145*

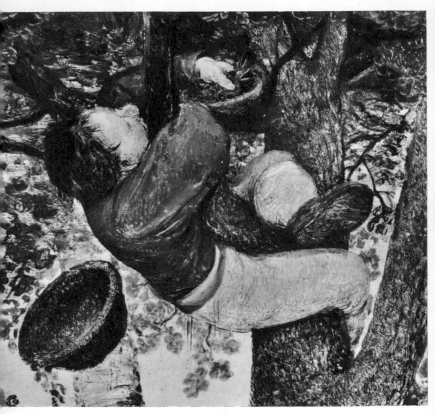

Plate 148. *Detail of plate 145*

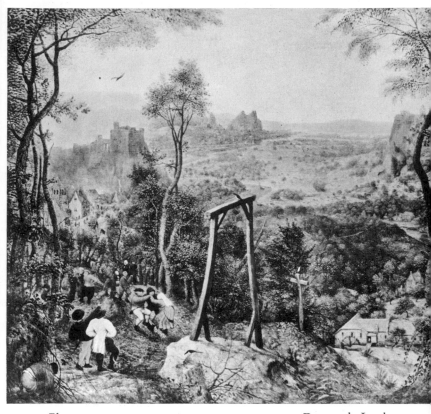

Plate 149. THE MERRY WAY TO THE GALLOWS, Darmstadt, Landes-
museum

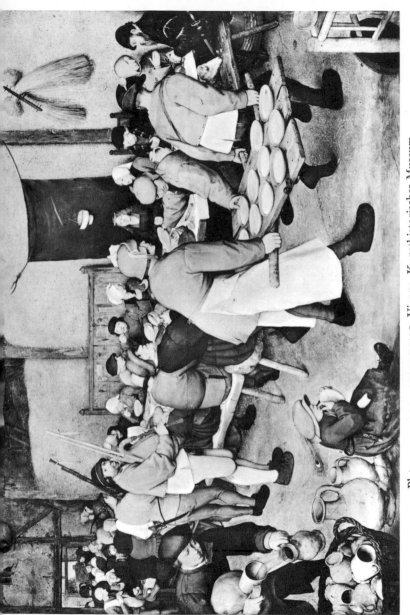

Plate 150. PEASANT WEDDING, Vienna, Kunsthistorisches Museum

Plate 151. *Detail of plate 150*

Plate 152. *Detail of plate 150*

Plate 153. *Detail of plate 150*

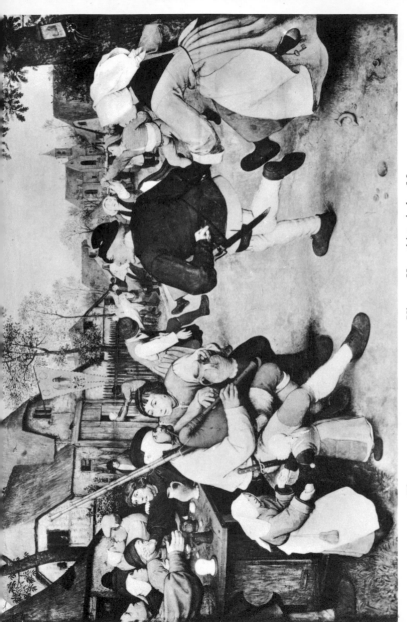

Plate 154 · THE PEASANT DANCE, Vienna, Kunsthistorisches Museum

Plate 155. *Detail of plate 154*

Plate 156. *Detail of plate 154*

Plate 157. *Detail of plate 154*

Plate 158. STORM AT SEA, Vienna, Kunsthistorisches Museum

Plate 159. *Detail of plate 158*

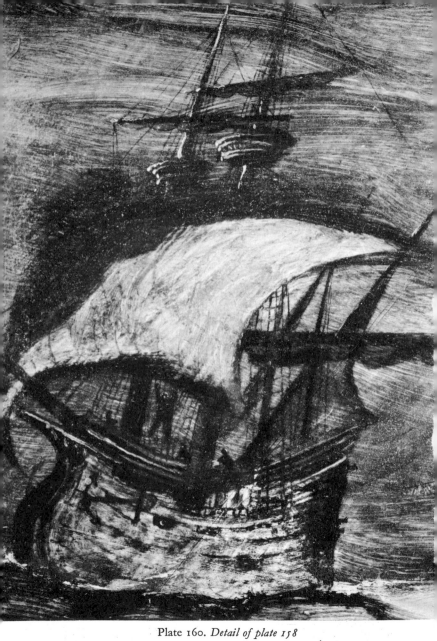

Plate 160. *Detail of plate 158*